May 2005

Bob

A token of appreciation from colleagues in the Borders! Best wishes and hope this will inspire you to come back and visit!

"next will miss our at wed clinic neurologist. Best Wishes
Jonathan

Thankyou very much for your help clinically and managerially in attending Dr Malcolm
Lynne

All the best. Thanks for all your input.

Paul S

I bet you will miss the Borders catering! Thank you for everything you will be missed.
Olive

Thanks for all your help – Much appreciated

Thank-you for all your support to the Borders.

Charlene Gordon

HEARTLAND

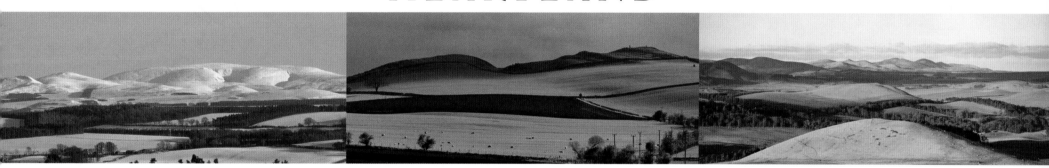

IMAGES OF THE SCOTTISH BORDERS

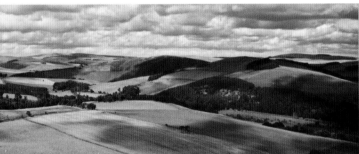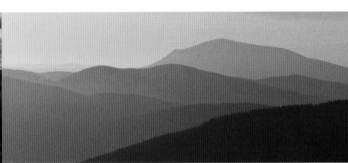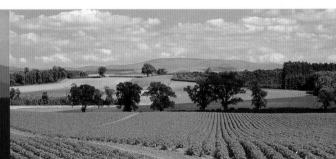

PHOTOGRAPHS BY LIZ HANSON
WITH TEXT BY ALISTAIR MOFFAT

HEARTLAND

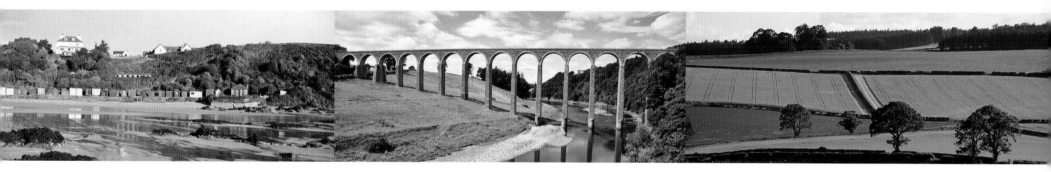

IMAGES OF THE SCOTTISH BORDERS

DEERPARK PRESS
SELKIRK

First published in Great Britain in 2004 by Deerpark Press

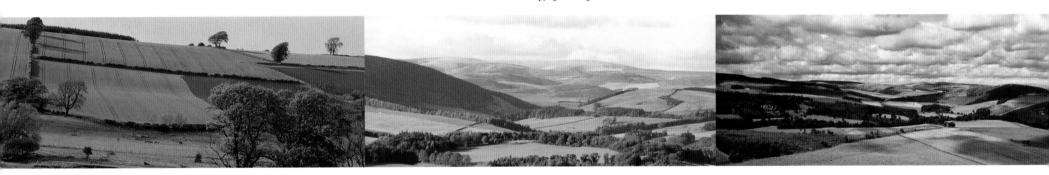

A CIP catalogue record for this book is available from the British Library.

ISBN 0-9541979-1-7

Printed in Hong Kong through World Print Limited,
151–153 Hoi Bun Road, Kwun Tong, Hong Kong.
Designed and typeset by Mark Blackadder
and edited and proofread by Kate Blackadder.

Deerpark Press
The Henhouse
Selkirk TD7 5EY

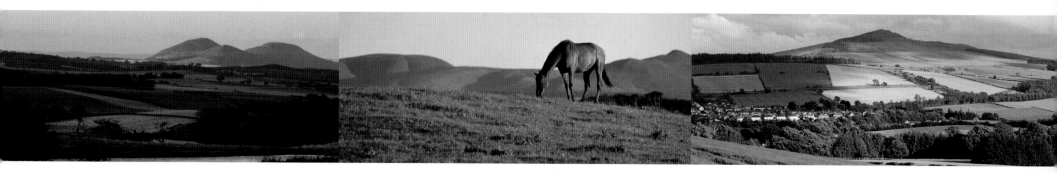

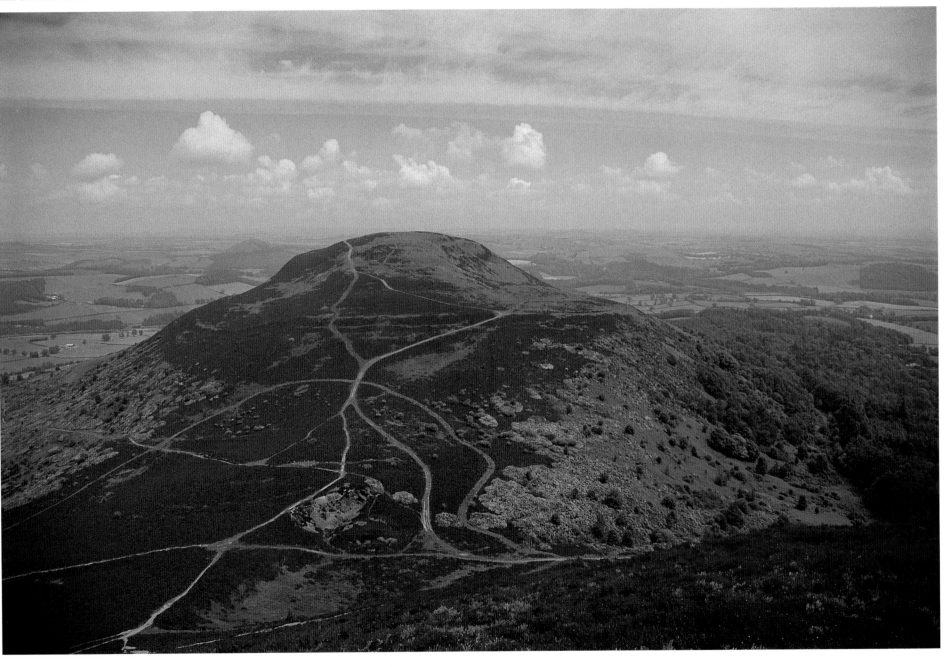

6

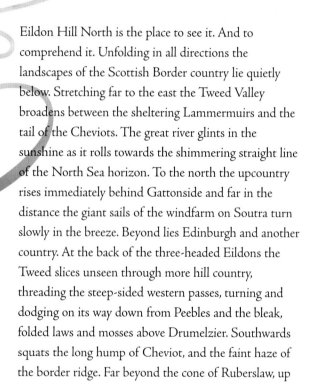

Eildon Hill North is the place to see it. And to comprehend it. Unfolding in all directions the landscapes of the Scottish Border country lie quietly below. Stretching far to the east the Tweed Valley broadens between the sheltering Lammermuirs and the tail of the Cheviots. The great river glints in the sunshine as it rolls towards the shimmering straight line of the North Sea horizon. To the north the upcountry rises immediately behind Gattonside and far in the distance the giant sails of the windfarm on Soutra turn slowly in the breeze. Beyond lies Edinburgh and another country. At the back of the three-headed Eildons the Tweed slices unseen through more hill country, threading the steep-sided western passes, turning and dodging on its way down from Peebles and the bleak, folded laws and mosses above Drumelzier. Southwards squats the long hump of Cheviot, and the faint haze of the border ridge. Far beyond the cone of Ruberslaw, up and over the other side, begins the cold, grim moorland of northern England and the old Roman wall that kept us in and kept us out. These are the limits of this story, the frontiers of a heartland, a home-place beloved by many.

Up on the hill it is quiet. Most climbers who reach the summit seem to be on the way to somewhere else and once they have replaced their bottle of water in a day-glo backpack, they rarely linger. Always there is a wind on Eildon Hill North and it deadens the traffic noise from the Melrose bypass to a barely discernible hum. Sometimes a bird shrieks or a rabbit scutters for cover, but these appear only to counterpoint the peace of the place, not disturb it.

But all around there are voices to be seen, the whispers of nameless people who made the landscapes that begin at the foot of the hill. Miles of dyking, fencing and hedging lead the eye into the distance on

every side, and they were built and tended by people whose identities have seeped back into the ground they worked on. The stands of trees, the dense regiments of pines and the edging shelter-belts were all planted by men whose names are remembered in no history book. In the Border towns, who were the women who worked in the Hawick mills, who made the tweed and hosiery that ensured the business thrived? Who were the men who laid out the Berwickshire roads, built the tenements in Galashiels, chiselled the beautiful mason work at Floors Castle or helped raise the viaduct at Leaderfoot? No-one now knows, their names are lost. Yet what they did is not. These people made these landscapes and townscapes and they are their common monument. Most of them were Borderers whose voices have long been stilled, but the photographs in this book are eloquent and in describing the seasons of this beautiful place, they speak for them at last. And when

the narrative attempts to describe the character of this landscape and its people, it will turn those ancient whispers into celebrations.

Geology shapes everything because it shapes the land. And because Scotland's geology is divided into three clearly distinct zones, its history and historical attitudes have been moulded accordingly. The Highlands, the Midland Valley and the Southern Uplands have been home to regional cultures which have often clashed and certainly contrasted with each other. Much more attention has been given to the Highland/Lowland divide because it has led to relatively recent armed conflict, and because the Gaelic language has described a very different – and attractively romantic – culture. Much less heed has been paid to the differences between the Midland Valley and the Borders. After all, the two peoples speak approximately the same language and in any case the numbers are insignificant.

Too few live in the Borders for it to matter much, or indeed to have been much of a threat in the past. It is no accident that all of the cities, most of the industry and intensive farming, the universities, television and newspapers and most of the people of Scotland live in the Valley. Geology made it so. South of the Southern Upland faultline, running from Ballantrae in the west to Dunbar in the east, there is wild hill country, itself a natural barrier. And below the central valleys of the Tweed and Teviot lies another frontier made by geology, the Cheviot Hills, a habitat every bit as bleak and hostile as the higher mountains north of the Highland faultline.

It may be said, even at this early moment in the story of the Borders, that geology formed important facets of our character. Living to the south of the Midland Valley, a powerful material and cultural centre, Borderers are in a minority and often show a prickly

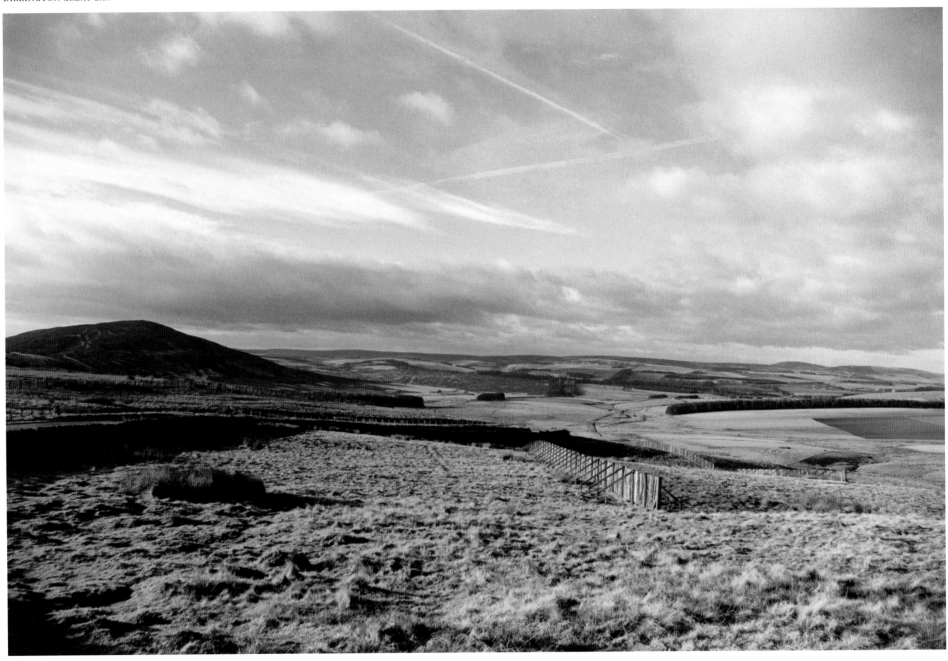

awareness of that. There is also sometimes a lack of confidence, a sense that the city's numbers will always win, that whatever is attempted is always against the odds, always likely to be second-best. This is sometimes mirrored by a patronising attitude from the cities of the Midland Valley, a view of the Borders as a land of quaint country cousins, a place always about 30 years behind the times. One of many historical ironies is that Scotland as a whole is treated in precisely this way by England, and perhaps in Edinburgh and Glasgow that creates a knock-on need for someone for them to look down on. To an extent the teutchers of the Highlands and the hayseeds of the Borders have met that need, occasionally all too willingly.

But geology has had beneficial effects. Wild hill country breeds tough and resourceful people and arable agriculture needs a dogged, day-in, day-out stubbornness for it to be successful. The people who

quietly created the lineaments of the landscape did their hard work unobserved, unapplauded, unacknowledged, and because they loved it. And for many centuries, the nature of the landscape disabled good communications outside the Borders, turning the communities in on themselves, but also binding them together into a cohesiveness which they have never completely lost. Borderers may squabble entertainingly amongst themselves, but if ever an outsider offers a critical word, they will turn as one on him or her.

The Borders has its own internal faultlines; town and country, ploughman and shepherd, and the eternal rivalry between its towns. But these are incidental differences when compared with what lies beyond the Lammermuirs and the Cheviots. The Borders is bounded by its own borders, and these came about because the area formed part of another, much older frontier. The surface of the Earth was very different 450

million years ago. What became northern Scotland was originally attached to *Laurentia*, a huge but unstable continent which eventually moved to join the North American landmass. What became northern England was completely separate at that time and part of an African and Southern European continent. Between these two great landmasses lay the *Iapetus Ocean*. And submerged beneath its waters lay the land that was to become the Borders.

As the crust of the Earth cooled, the continents containing the north and south of Britain moved slowly closer to each other. The floor of the Iapetus Ocean was squeezed and the Borders rose up to become dry land. Volcanoes erupted, spewing out lava to form the Pentland Hills, St Abb's Head and the Cheviots. About 370 million years ago, the Old Red Sandstone of the eastern Borders was laid down and outcrops of marine fossils can be seen at Jedburgh and Cockburnspath.

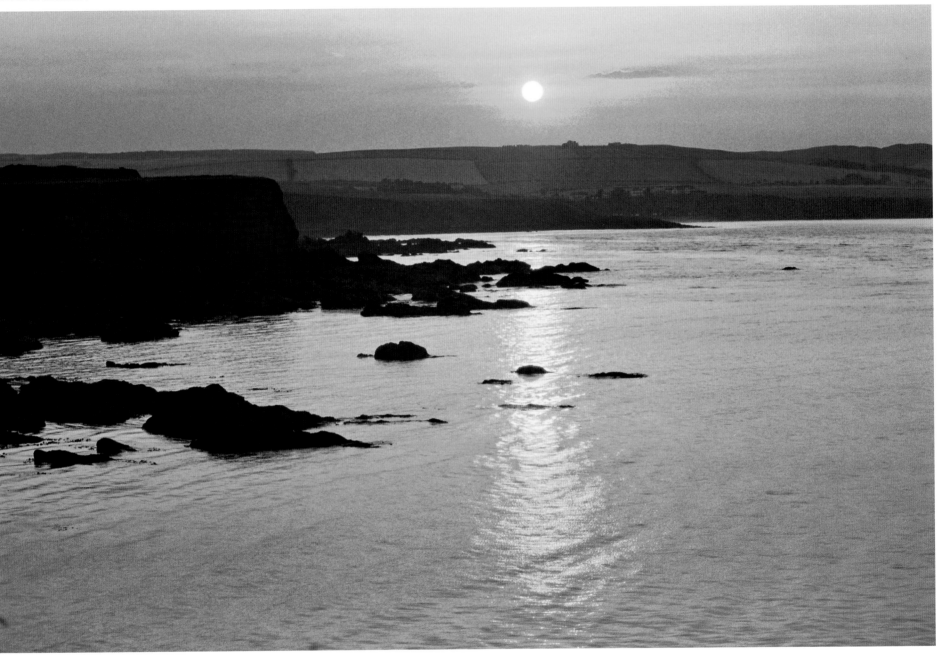

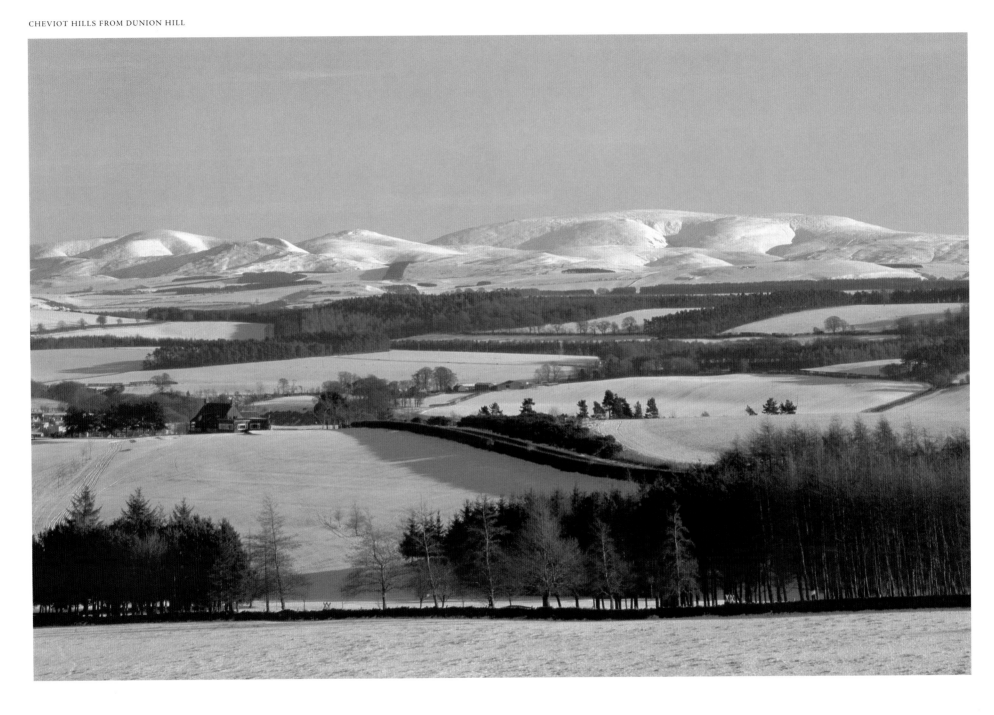

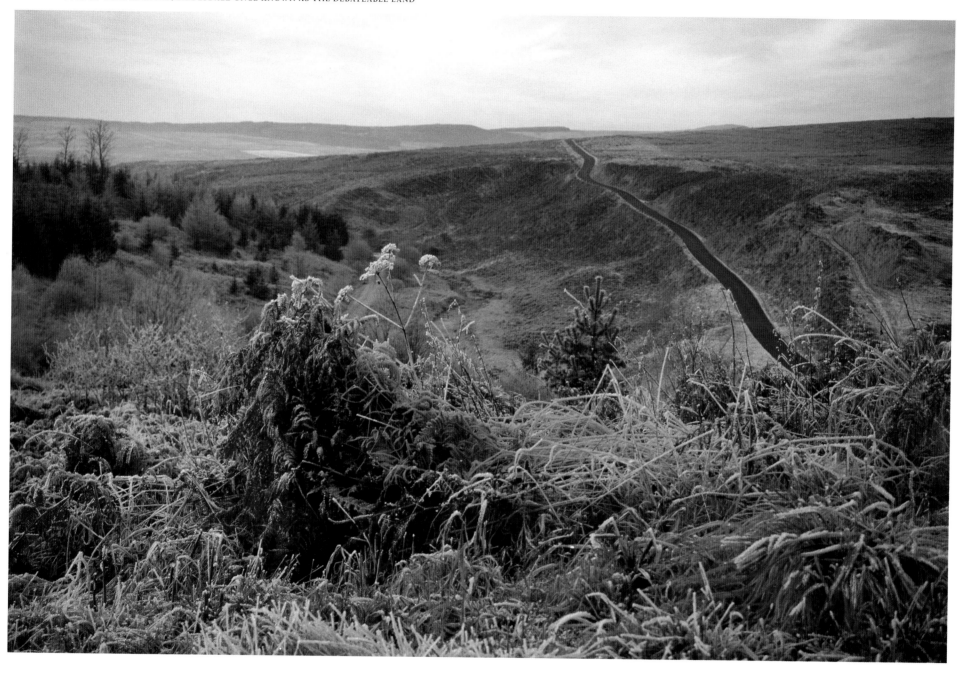

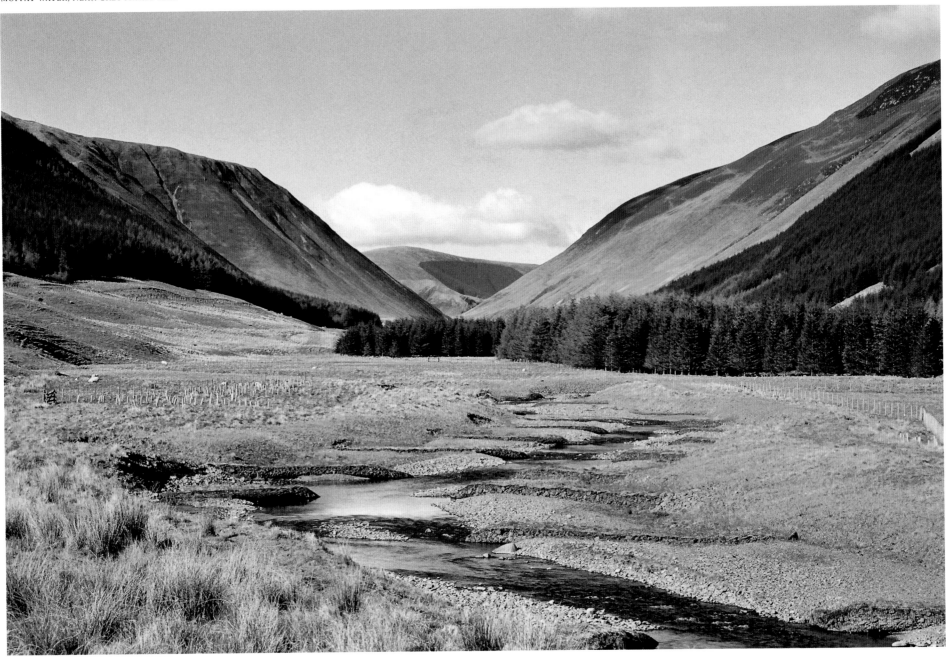

16

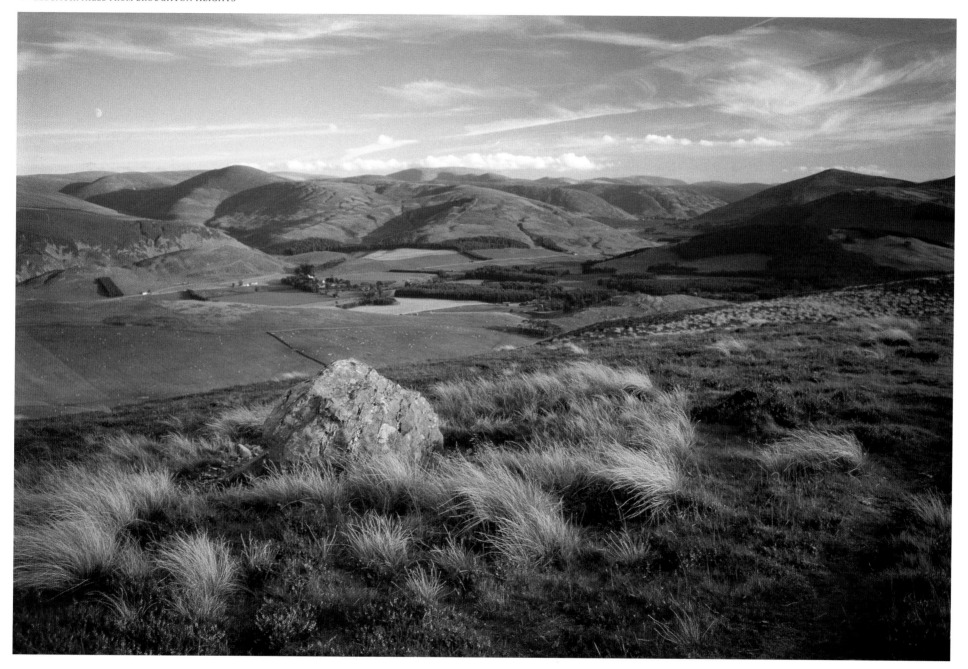

More violent shifts in the Earth's crust caused more volcanoes to burst through and the Eildon Hills and Ruberslaw were made, the latter an obvious volcanic cone. Sixty-five million years ago the last bouts of seismic activity completed the fundamental north-east to south-west orientation of the Border hills and river valleys. What these complicated convulsions show is something simple. The Borders first came neither out of England nor Scotland, but rose from the depths of an ancient sea, independent of either. And buttressed by the enfolding hills, that independence has never withered.

But the landscape was not yet recognisable. In the last 2.5 million years, comfortably within the continuum of human experience on the planet, at least 20 ice ages have occured. Large areas of the Earth's surface have become covered with ice and snow and such populations of people and animals to survive were driven towards the equator. At its height, around 16,000BC, the last Ice Age engulfed all of what is now Scotland, reaching as far south as Wales and the English Midlands. And beyond the edges of the ice-sheets and snowfields, there stretched immense horizons of tundra.

The ice-domes laid a crushing weight on the land. Over the Borders it may have been half a kilometre thick in places, especially around Broad Law and the Tweedsmuir Hills. Storms blew hard and constant as flows of cold air created low pressure areas around the lower slopes of the domes. Sometimes moving at a rate of one kilometre a year, glaciers rumbled over the surface of the land, carrying rocks and debris inside them, scraping along like geological sandpaper. The ice erased all traces of human activity in the Borders before 18,000BC and its effects are still being felt now.

When such an immense weight pressed down on the land, it sank considerably. Where the European ice-domes were thickest, over northern Sweden, the land was 800 metres lower than it is now. It is still rebounding, as are parts of Scotland. At the rate of more than half a metre a century, the area around Dunbar is still rising. And there was another radical consequence. Like a large man sitting on one end of a long cushion, the ice had the effect of pushing up the land which had remained ice-free. This created what is now a lost part of the European continent. Out in the North Sea, the shallows of the Dogger Bank cover the last submerged remnant of a huge area of dry land, what archaeologists have called *Doggerland*. It was immense, its coastline stretching from Denmark in the east to link with Britain and form a large peninsula projecting from north-west Europe. By the centuries around 5,000BC Doggerland had sunk to become a large island, and its days were numbered. No-one knows when final inundation took place but it may have been overwhelmed by a tsunami

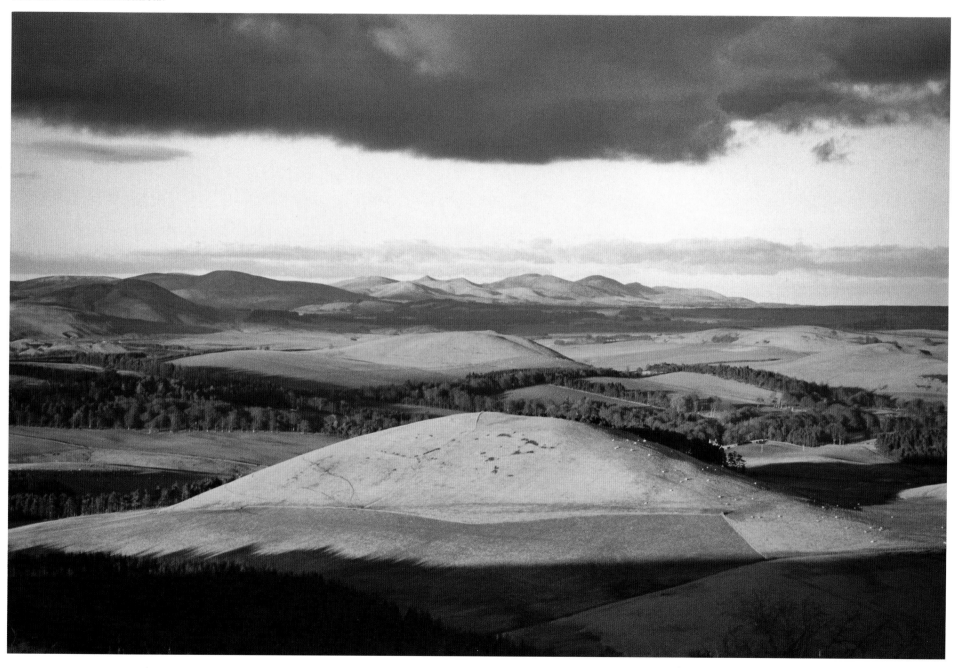

20

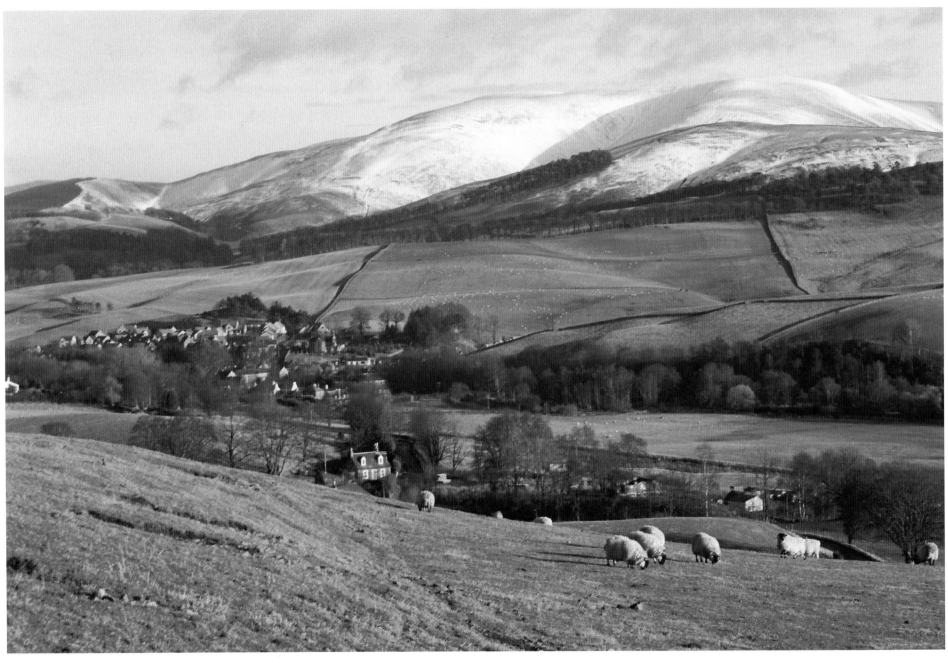

or tidal wave caused by an undersea landslide.

After 16,000BC, when the Last Ice Age had reached its zenith, the weather began to improve. The ice-domes groaned and cracked and the Borders started to thaw. As meltwater flowed in torrents, the familiar landscape of hills, valleys, plains and sea-coasts emerged. Grinding their way north-eastwards from corries in the Tweedsmuir Hills and the Cheviots, glaciers moved across the landscape, sometimes changing the configuration of valleys, altering the courses of streams and rivers and depositing many thousands of tons of debris where they slowed and stopped. Before the Last Ice Age the Kale Water flowed into the Bowmont and not the Teviot, and the Tweed took a different course before Peebles, flowing down the Manor Valley instead of through the Neidpath Gorge.

Temperatures remained cold at first, and in place of the ice a tundra stretched over the Borders. In the few centimetres of soil above the permafrost, small plants flourished in a short growing season. But even this was enough to bring reindeer and herds of wild horses north for summer grazing. And behind the migrating herds their predators followed, including the first pioneers to venture into the Borders landscape for millennia.

It turned out to be a temporary respite. Around 9,400BC the weather began once again to deteriorate, storms blew and the cold crept back over the face of the land. What prehistorians call *The Cold Snap* was happening. Centring over Ben Lomond, the ice-domes were reforming and the glaciers flowed again from the slopes of Broad Law. The Cold Snap drove the pioneers south and the Borders emptied of animals and people.

By 8,000BC warmer weather had returned and the Borders landscape assumed its familar shape. As conditions improved, trees appeared. Dwarf willow was first, then birch and hazel, and by 6,500BC oaks and elms had joined them to form a dense wildwood. Like a temperate jungle, it carpeted the land in green as far as the eye could see. Because temperatures were higher and the weather generally less stormy than it is now, the tree-line reached up and over the highest hills. Even the top of Eildon Hill North will have been covered with smaller trees able to withstand the breeze.

The wildwood did not suit the flight animals of the open plains, such as reindeer, caribou and wild horse. As it spread and thickened, the herds moved north to places where there was less cover, where they could see predators at a distance. They were replaced in the Borders by the wild boar, the huge wild cattle known as aurochs, giant elk, red and roe deer and a host of other, smaller animals. Pioneer bands of hunter-gatherer-fishers followed them north probably by coasting up the North Sea shoreline, or perhaps sailing westwards from Doggerland. The wildwood had no tracks except those

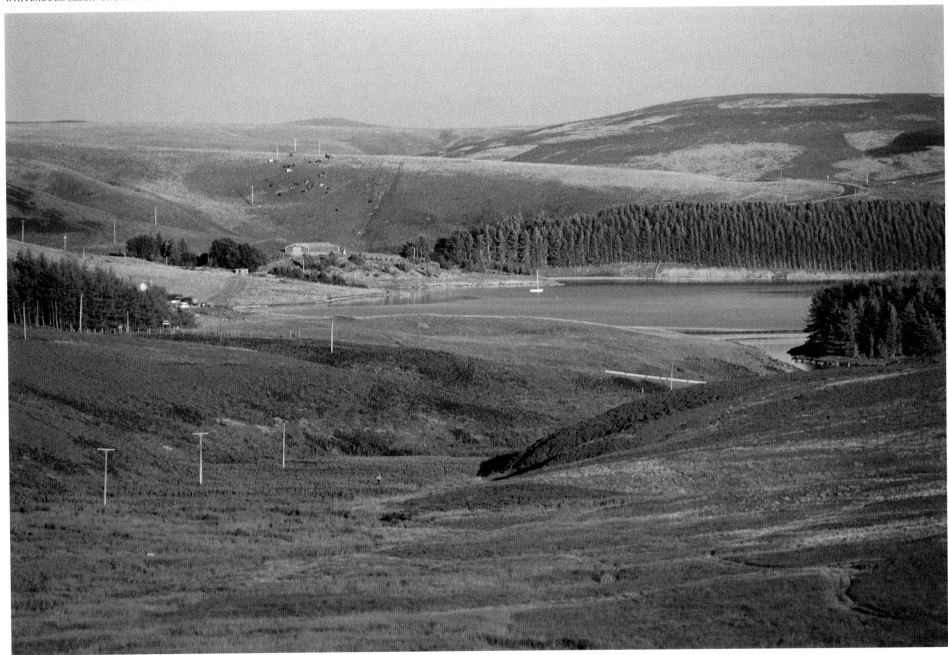

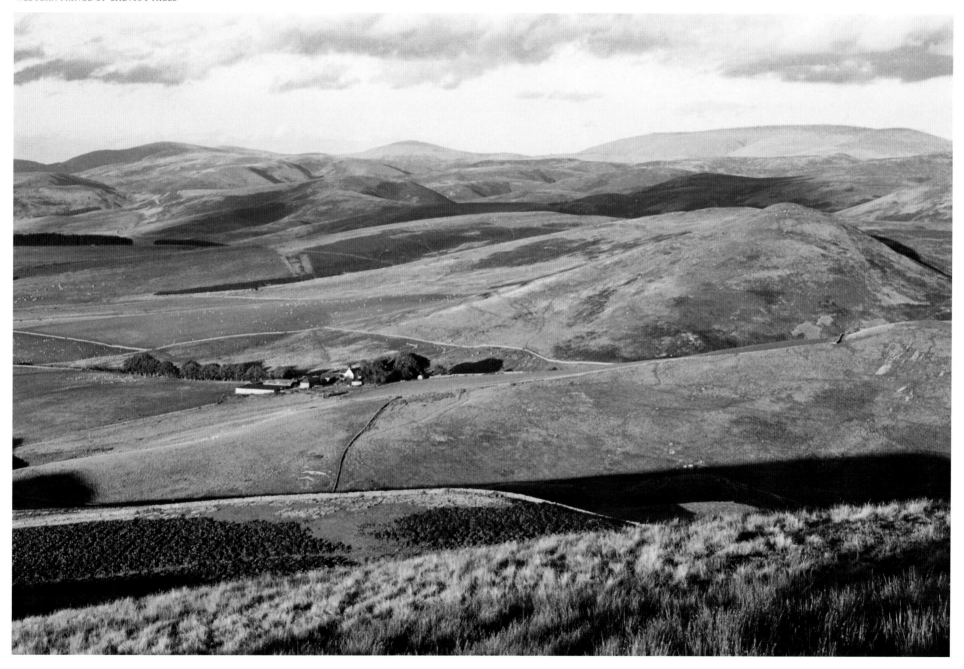

made by animals, and in the dense and shaded undergrowth, it was easy to get lost. When the pioneers first came across the mouth of the River Tweed, it opened as an invitation to make their way into the interior. On the river they were safe, quickly becoming familiar with its turns, islands, rapids, pools and large rocks. While they stayed in their boats and camped on the riverbank, it was impossible to stray. But if bearings were lost in the thick of the wildwood, a tree or a hill had to be climbed in search of landmarks.

Hunter-gatherer-fishers left only gossamer traces on the Borders landscape. They may have built permanent base camps near the river, but none have been found, and if they ventured further into the interior on summer hunting expeditions, they probably took tipis with them. Very like those used by North American Indians, they were pitched, used for a season, and then removed, leaving only the slightest disturbance on the ground, sometimes only a faint stain on the soil.

A much more emphatic footprint left by the early pioneers was their rubbish. Using stone tools made from flint or other hard, flaking stones, they were in the habit of discarding a good deal of debris. So-called chipping or flint-knapping floors have been detected along the courses of several Border rivers, and a particularly rich site was discovered at The Rink, where the Ettrick meets the Tweed.

A confluence of such importance was a well-known meeting place, probably the location of a permanent base-camp occupied all year round by a band of hunter-gatherer-fishers. The earliest settlers in the Borders travelled by boat wherever possible, for speed, safety and so that they could carry cargo. Prehistoric dugout canoes have been found in a number of places in Britain, reasonably well preserved in boggy conditions. But the most common form of river transport has left no mark on the archaeological record. It is highly likely that the pioneers who first settled the Tweed Valley navigated their way upriver in curraghs. These boats are still made in Kerry, in south-west Ireland, and their traditional design has varied little over millennia. Built on a frame of hazel rods, tied together like basketwork, they are made watertight when wet hide is stretched over it and caulked with resin or fat. (The only major modern change is the use of canvas instead of hide.) A curragh can be made in a morning by an experienced hand, and be ready for use in a day. Easily repaired and replaced, they have the great advantage of being very light so that they sit on top of the water, taking a draught measured in centimetres. This enables them to move easily and quickly up a river of varying depth. When the course becomes rocky or rapid, portages along the riverbank to better water are easy. Two men can carry a curragh and its cargo. And turned upside down, it makes an excellent

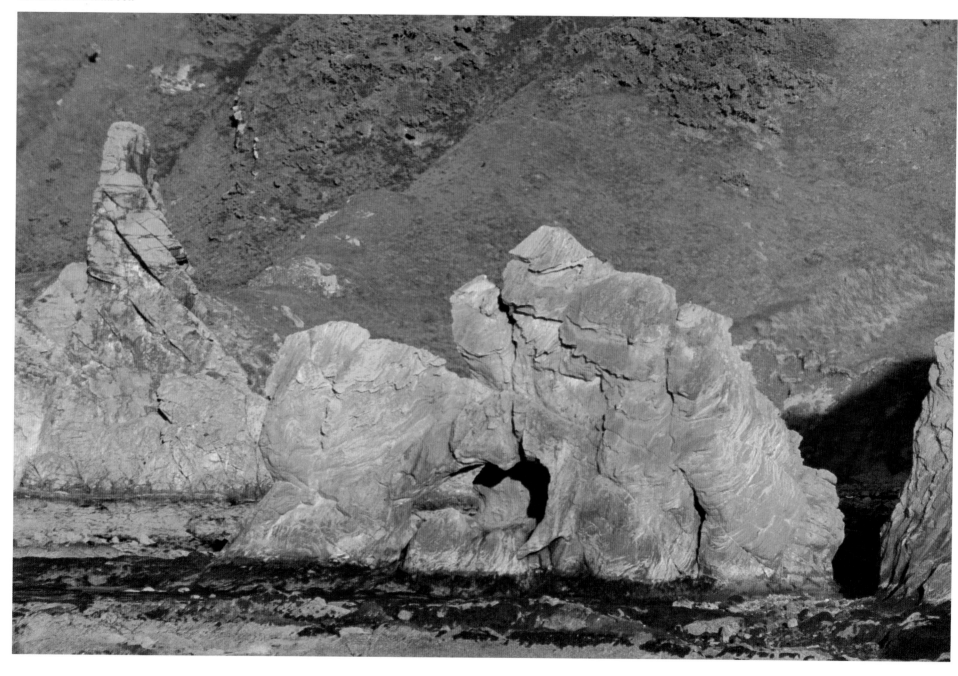

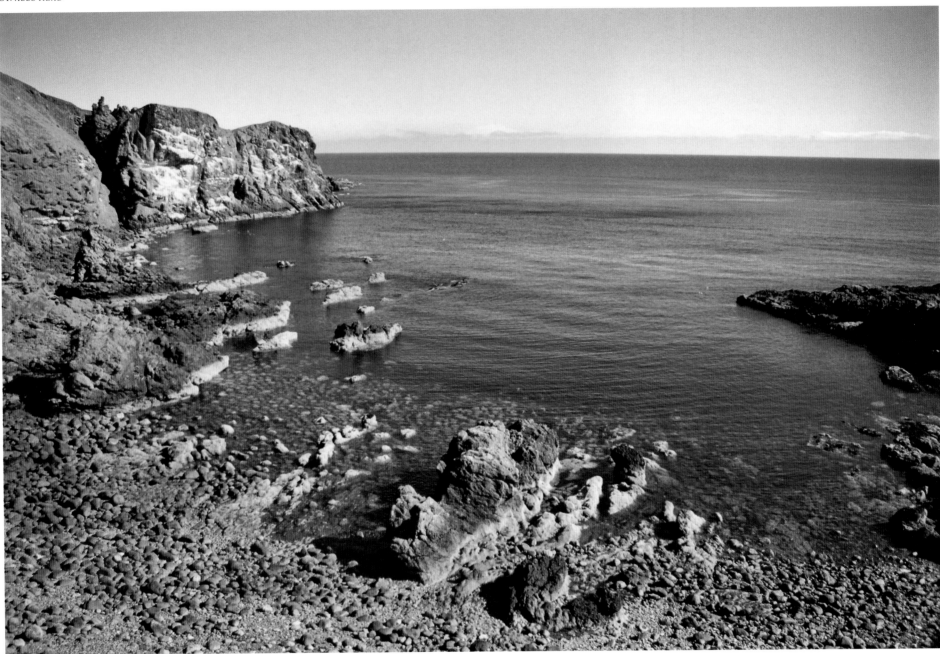

overnight shelter in bad weather.

The rivers of the Borders were larders as well as highways, and another significant reminder of the fleeting presence of the hunter-gatherer-fishers lies just below their surface. When these men and women went after salmon and trout, they did not use fishing rods and gaudily dressed flies. They set traps. At places in the current where they observed fish moving, traps made from willow withies guided the salmon and trout (and anything else edible) into underwater pens where they could be speared when needed for supper. They resembled very large versions of lobster pots and worked on similar principles. Willow traps have of course long since perished. But the stone *croys* and their *yiddies* made by the early settlers have survived and, it seems, are still used by modern poachers. Our ancestors were adept at making nets out of organic materials, but they often had difficulty in casting them. When thrown out into the middle of the river, the current tended to drive them back against the bank. So they built croys out of boulders, narrow stone piers which curled out into the river to create an area of still or slack water behind them. Fish swam into these yiddies to gain respite from swimming against the strong current and when they poked out beyond the croys to feed, the prehistoric fishermen were waiting with their nets. Croys can still be seen at Melrose and at Norham.

The rivers have run through the lives of Borderers for millennia. Tributaries feed the Tweed like veins and arteries as it glides towards the sea at Berwick. All of the major towns are built on the rivers of the Borders, evening walks are taken along its summer banks or over bridges, and in the winter the elemental power of sudden spates replaces the picturesque with danger and damage. Their names are very old, almost certainly the oldest words used in daily speech. For 400 generations they have spoken of this place: Lyne, Ettrick, Yarrow, Ale, Kale, Rule, Jed, Slitrig and Teviot, Gala, Leader, Blackadder, Whiteadder and Eye. The name of the Tweed appears to pre-date the Celtic languages spoken in the Borders in the first millennium BC and it is related to an Indo-European root-word, Tavas or Taus, which means *The Surger*. Perhaps that is how the early pioneers saw the Tweed.

Few other echoes of their lives impact on our own, except for one. Far from being distant shadows who flitted across the prehistoric landscape, the pioneers who first came up the Surger are in fact our close relatives. Comprehensive studies of our DNA have shown that 80% of the population of Britain is descended directly from the hunter-gatherer-fishers who sailed their curraghs up the rivers and pitched their tents on their banks, or simply walked over Doggerland to reach what became Britain.

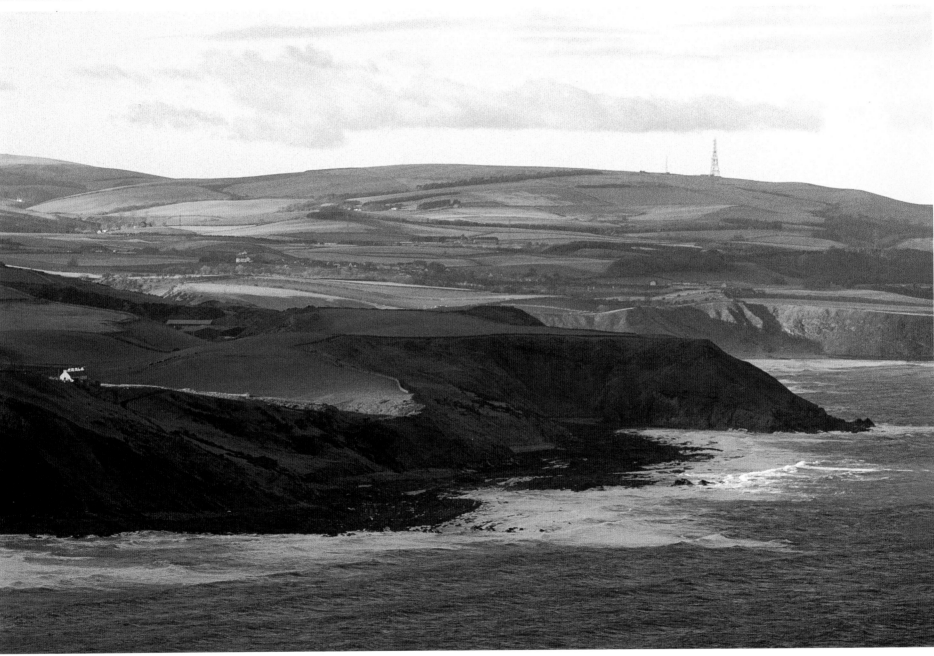

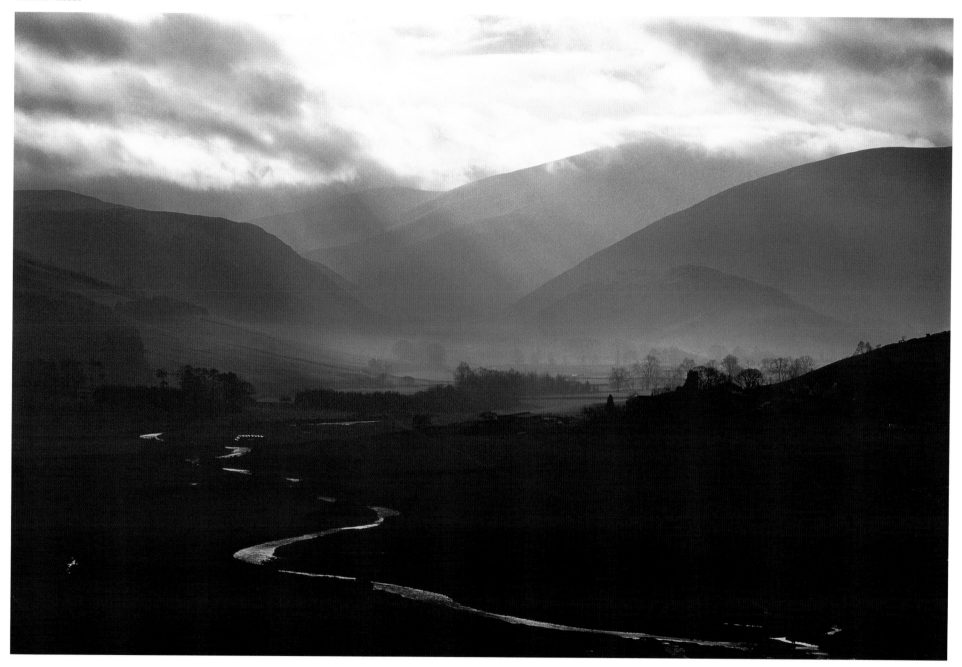

30

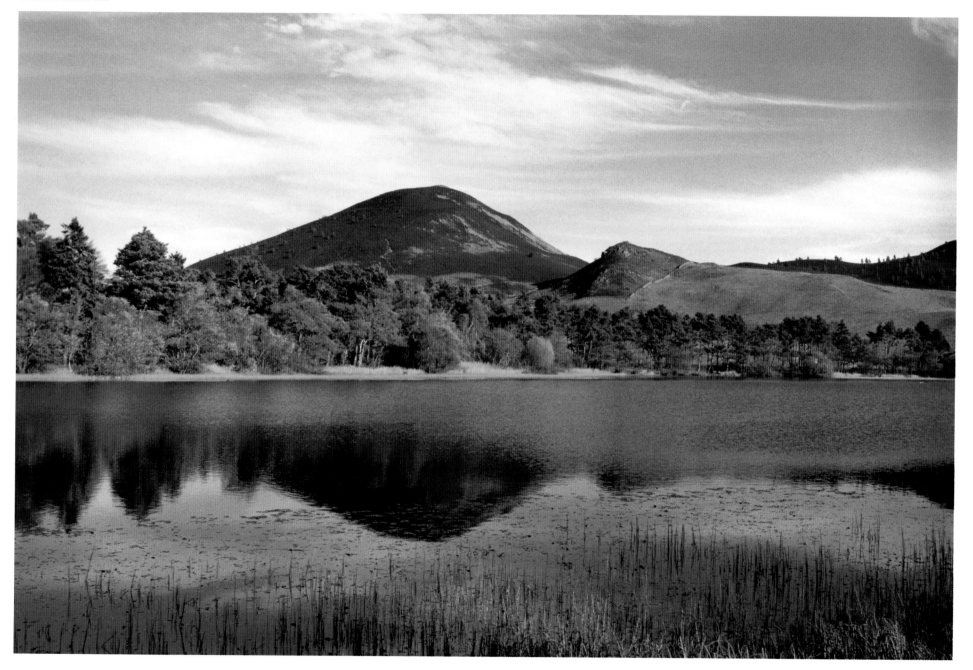

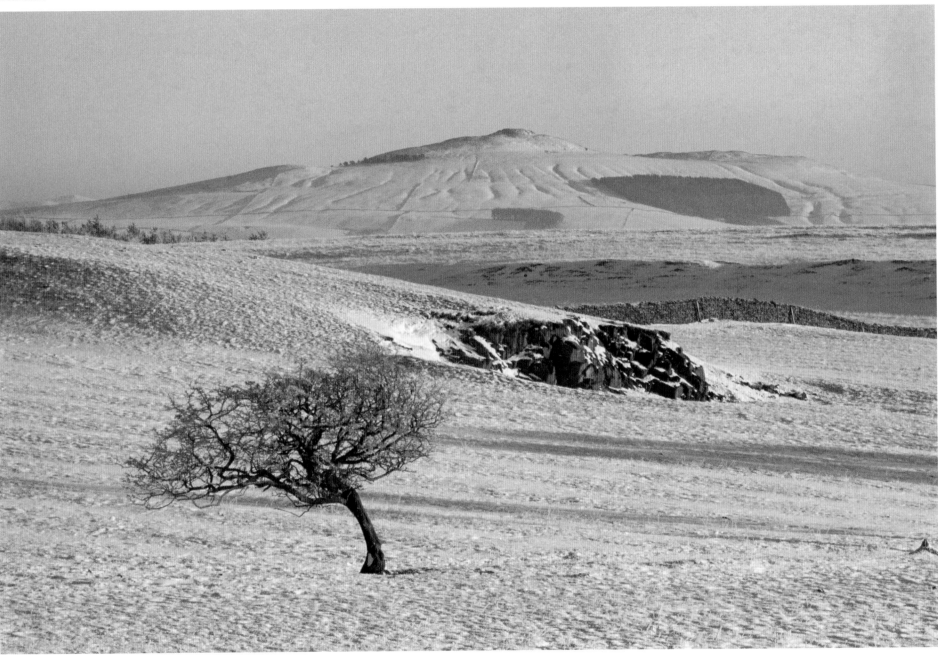

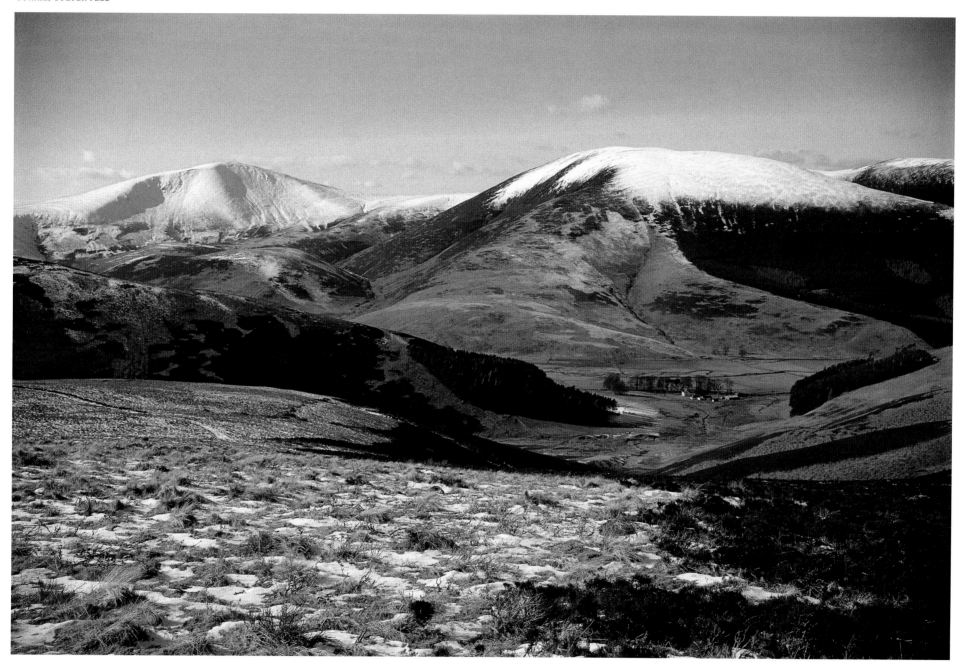

The conventional wisdom used to hold that the British were a unique mongrel race made up of many arrivals throughout our long history; Celts, Angles, Saxons, Vikings, Normans and so on. But it turns out that these elites, small groups of men arriving in small boats, had only a marginal impact on our genetic mix. Our ancestors were not adventurers or conquerors, but the men and women who gathered berries and fruits in the wildwood, who tracked animals in its glades, who led short and anonymous lives on the banks of our rivers and streams. In large part Borderers of the 21st century are their children, the direct descendants of the people who first came here after the ice-sheets and the snowfields finally retreated, around 8,000BC. We are, it seems, who we were.

This astonishing and unarguable scientific fact allows at least one observation on character. Borderers love the shape of the land they live on. It seems always to fill the eye, be endlessly engaging, constantly changing with the transit of the seasons, difficult to leave or forget; the view of the Eildons from Lilliardsedge, the Tweed at Dryburgh, the majestic rocks and sea-cliffs at Coldingham, the windswept grandeur of the Ettrick. And that love is deep, perhaps 400 generations old, printed on our DNA.

It would be a mistake, and disrespectful, to imagine that our prehistoric ancestors were much different from us, either in their shared love of the Borders countryside, or in any other important way. In appearance they resembled the medieval population, with an average height of 5 foot 7 inches for men and 5 foot 3 inches for women, and their life expectancy was short. Because of the dangers of childbirth, women did not get much beyond 20 on average, and men died around 26 or 27. Anyone who survived beyond 40 was exceptional, and may well have been venerated for that reason. But they were not the grunting cavemen of popular misconception, gnawing at bones and running around in ragged animal skins. Like the forest Indians of the eastern United States, the hunter-gatherer-fishers were skilled woodsmen who wore close-fitting buckskin tunics and leggings for warmth and ease of movement through the undergrowth.

And in most other important ways, our ancestors were like us. We should no more judge them by their technology than we would judge the ancient Egyptians or the Greeks or the Romans. A culture which does not use the mobile phone can still communicate well. And in the still of a fine summer's evening, they will have sat down on the banks of the Tweed at Dryburgh, after a good supper, thrown stones in the water and remarked to each other how beautiful it was.

By the centuries around 4,000BC, a younger genetic cluster in the prehistoric population shows up in the

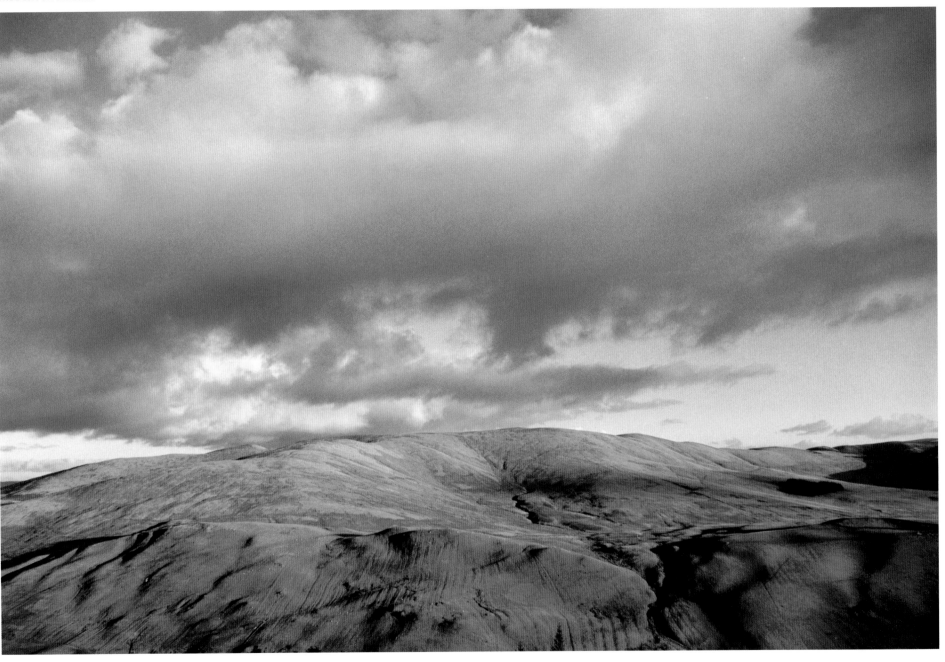

DNA studies in Britain. Originating in modern Iraq and northern Syria, it seems that these people brought new ideas with them, stimulating the greatest revolution in our history, a change which altered our cultural direction radically. And yet the new people who brought it are anonymous and the processes by which it happened are uncertain. Farming came to Britain and to the Borders around 4,000BC, and it changed the landscape forever.

Hunter-gatherer-fishers had built permanent base-camps before that date. An extraordinary timber roundhouse was recently discovered at Howick on the north Northumberland coast which could not have been anything else. And they also managed the wild resources they depended on for survival. Hazelnuts and shellfish were cropped in huge quantities, trees coppiced to provide straight wands of wood and when a hunter killed an animal, he or she avoided pregnant females and always prefered mature or older males. But around 4,000BC new ideas arrived to convert these marginal habits into something much more systematic, and they made an immediate impact.

At Whitmuirhaugh Farm, by the side of the Tweed near Kelso, aerial photography has detected a cropmark which tells a fascinating tale. There have been three others like it found in Scotland (so far); two at Balbridie on the River Dee near Aberdeen and one at Claish Farm on the River Teith near Callander. Excavations at Balbridie and Claish have uncovered the foundations of very substantial timber halls dating to c3,800BC. And at Whitmuirhaugh archaeologists are certain that they have come across another.

More like the great Anglo-Saxon halls sung of in poems such as *Beowulf* than anything prehistoric, these structures are comparatively large at 25 metres long and 10 metres wide. It seems that they were home to a community of farmers. Food was stored, pottery made and animals stalled in what must have seemed a huge, monstrous, man-made structure to those who had seen nothing like it before. And few had. For the evidence suggests strongly that the halls at Whitmuirhaugh and elsewhere were built by immigrants from north-west Europe, or perhaps from the fast-disappearing island of Doggerland. Similar structures were built on German and Dutch river terraces and some of the grain discovered by archaeologists at Balbridie is of continental origin. It seems that new people arrived by boat at the mouth of the Tweed, and then ventured inland to prospect for the sort of place they had known on the banks of the Rhine or the Weser in Holland, Germany or Doggerland. People have been farming at Whitmuirhaugh for a very long time.

At first, it was of course a mixed agricultural economy. No-one in the Borders stopped hunting,

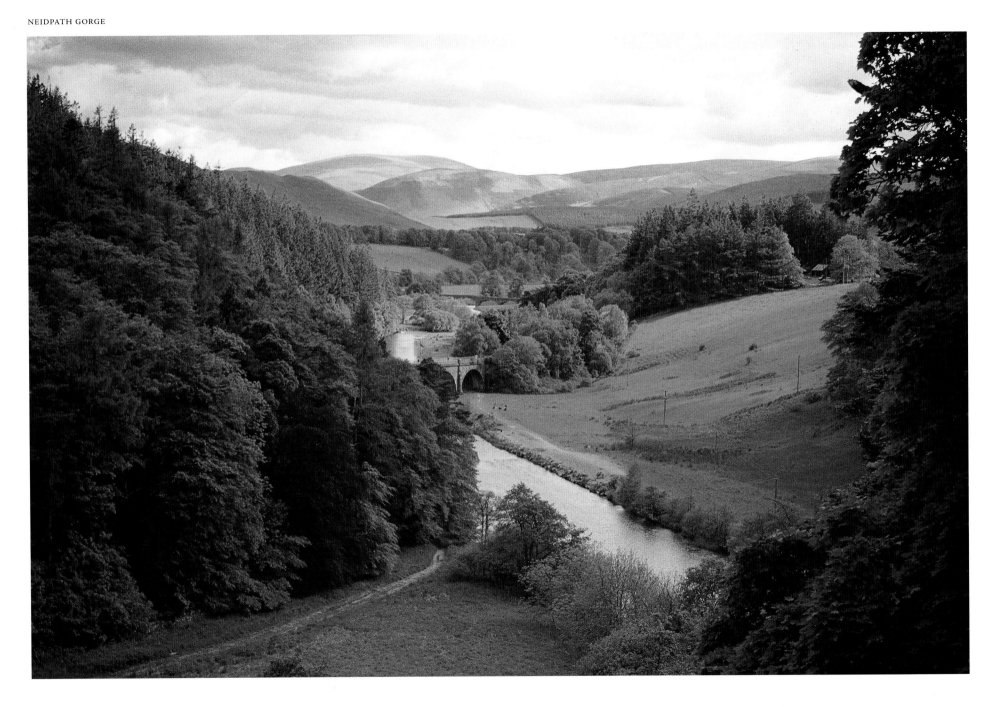

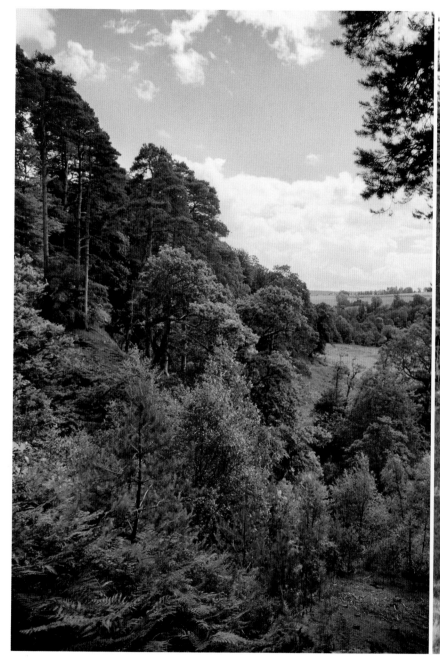

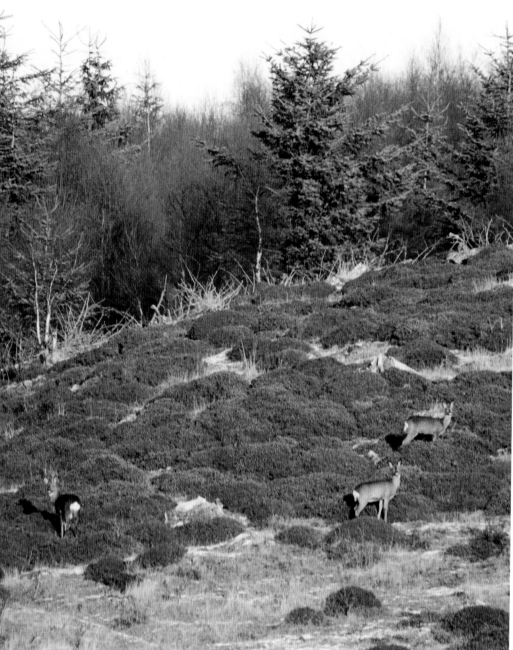

39

40

gathering or fishing, at least not if they had any sense. New farming techniques slowly added to what already existed. Domesticated animals, especially sheep, cattle and pigs, became important sources of meat, milk and hides. Grain was grown on small plots, partly for winter fodder and partly for human consumption. But no-one stopped using wild berries to flavour their porridge, or roasting venison or taking salmon from the wicker traps in the river.

All over the Borders the fourth millennium BC saw progressive woodland clearance to provide grazing for animals (whose constant browsing further inhibited tree growth) and fresh plots for sowing. Corn is a hungry crop and it exhausts the soil quickly, and early farmers probably moved on to new plots after only a season or two. Prime in this process was the flint axe, and it was an efficient tool. In a recent experiment in Denmark two men took four hours to clear 50 square metres of birch wood using only flint axes.

Population grew in the wake of woodland clearance and the advance of farming, and the way that population organised itself changed. As agriculture developed people began to acquire specialisations. Skills such as pot-making and working with hides became associated with only one or two people and society found ways of rewarding those not directly involved in food production. Land itself came to be regarded as a possession rather than a resource. And inevitably, as numbers increased, competition for good land arose. The deposits of these tensions can still be seen in the landscape in the form of long ditches and banks which acted as clear and unambiguous boundaries. Many of these go unremarked and are, in any case, very difficult to date. But Heriot's Dyke on the moors above Greenlaw appears to have been an ancient frontier between groups of farmers.

By 3,000BC monuments had begun to rise. Long cairns of stones were built on a few sites in the Borders, the most spectacular being the Mutiny Stones on a ridge of the Lammermuir Hills north west of Duns. Shaped like a comet, with a head and tail, it is large at 85 metres in length, 2.5 metres high and between 7.6 metres and 23 metres wide. It may have been a burial cairn, interestingly aligned on the same north-east to south-west axis as Border geography, and it was certainly a substantial undertaking requiring a great deal of well-organised communal effort probably directed by a ruling individual or elite. These people were powerful, able to organise large work gangs and feed them. The Mutiny Stones is a religious monument; although it is not known what ceremonies took place there, it stands early in a long line leading down to the Border abbeys, the Reformation churches and the Tibetan monastery at Samye Ling near Langholm.

As time went on and farming society waxed complex, more elaborate – but no less mysterious – structures were raised in the Border landscape. Above Peebles, where the Lyne Water is joined by the Meldon Burn before tumbling into the Tweed, there are the remains of a remarkable ceremonial centre. The confluence of the rivers and stream was an ancient meeting-place, a function remembered in the modern name of Sheriffmuir, where the Peeblesshire Militia mustered as late as the 19th century. Between the Tweed and the Lyne a long barrow of earth and stones was formed as a communal tomb some time in the fourth millennium BC. Two later standing stones were erected nearby and also two cairns, smaller than but similar to the Mutiny Stones. And then something very unusual was built between the north bank of the Lyne Water and the mouth of the Meldon Burn. Huge timber posts marked off and screened an area of about 20 acres. The intention was to demarcate a sacred area, a holy of holies of some sort, but what went on behind the screen of posts remains mysterious.

Henges were built in the Borders. Not pillars and lintels of stone, like Stonehenge, but circular ditches and raised banks to achieve a similar screening effect as at Meldon Bridge. It may be that wooden excarnation platforms were placed inside these henges. Most prehistoric burials of this period are of defleshed skeletons, and these strongly suggest a habit of exposing dead bodies on raised platforms where birds could peck and natural degeneration could take place well away from the reach of scavenging animals such as wolf packs. The bones were then buried or cremated or both.

Henges also appear to have had astronomical uses, and there is an alignment between the circle at Mellerstain, near Kelso, and the standing stones at Brotherstone Hill. Most are now ploughed out and detectable only as cropmarks. But the henge at Sprouston was almost certainly related to the timber hall at Whitmuirhaugh and may have been built by the descendants of the farmers who first moored their boats at the riverbank nearby.

Even though they are harder to remove than the ditches and posts of henges, the larger elements of stone circles and alignments, like those at Brotherstone, are still not numerous in the Borders. Perhaps the most atmospheric place, somewhere a fleeting sense of these forgotten mysteries might be had, is a small monument at Duddo in north Northumberland. Standing on a low ridge which looks both to the Cheviots and to the sea at Berwick, the stone circle is as carefully placed as any. But it is the stones themselves which take the place out of time. Five are large and over 40 centuries have been chiselled into remarkable shapes by the wind. Fluted, pockmarked and even defaced by modern hands, they

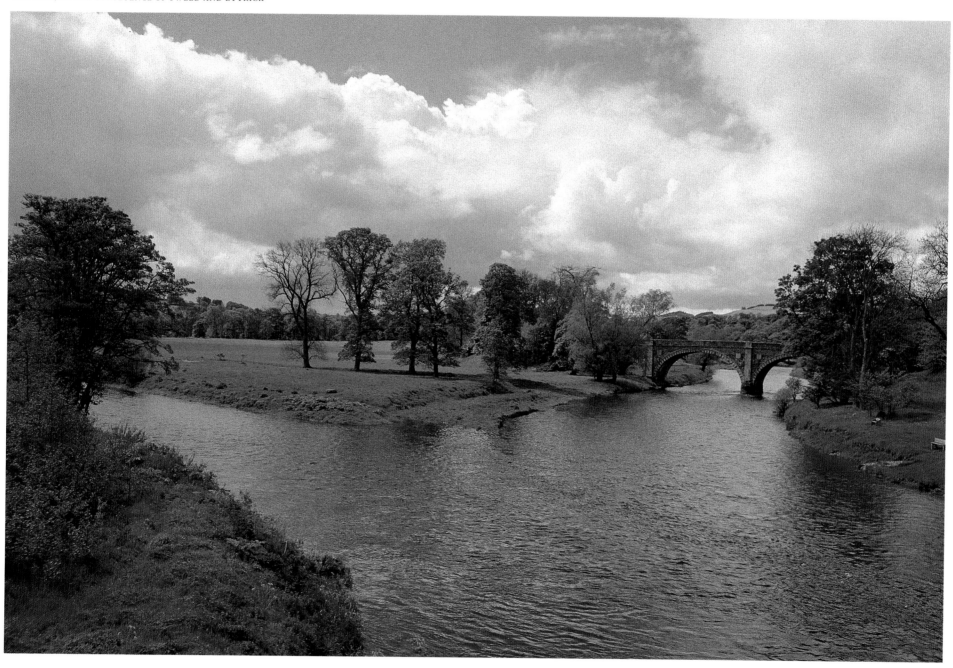

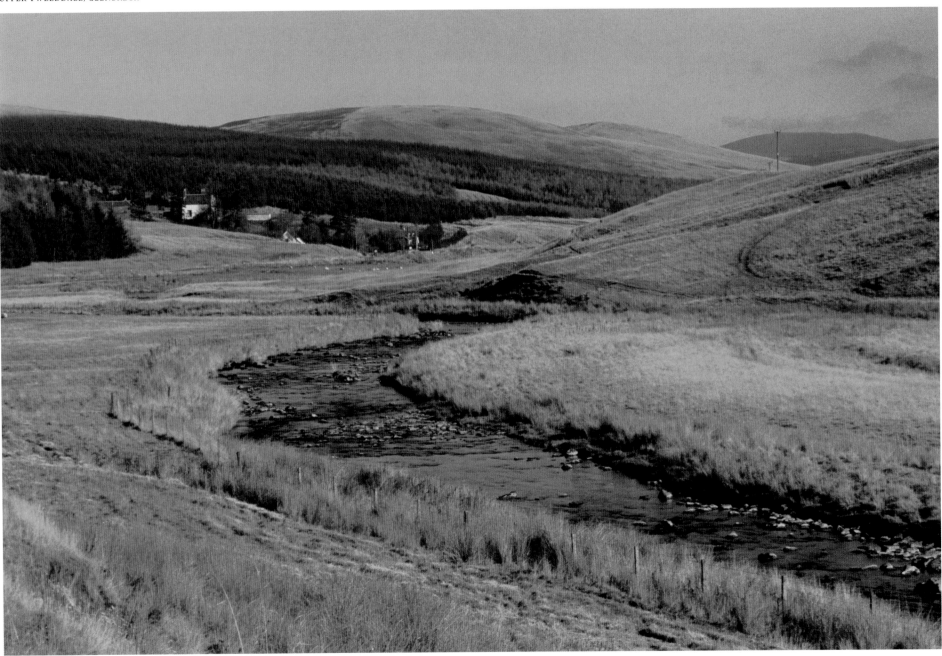

ALEMOOR RESERVOIR

MEGGET RESERVOIR

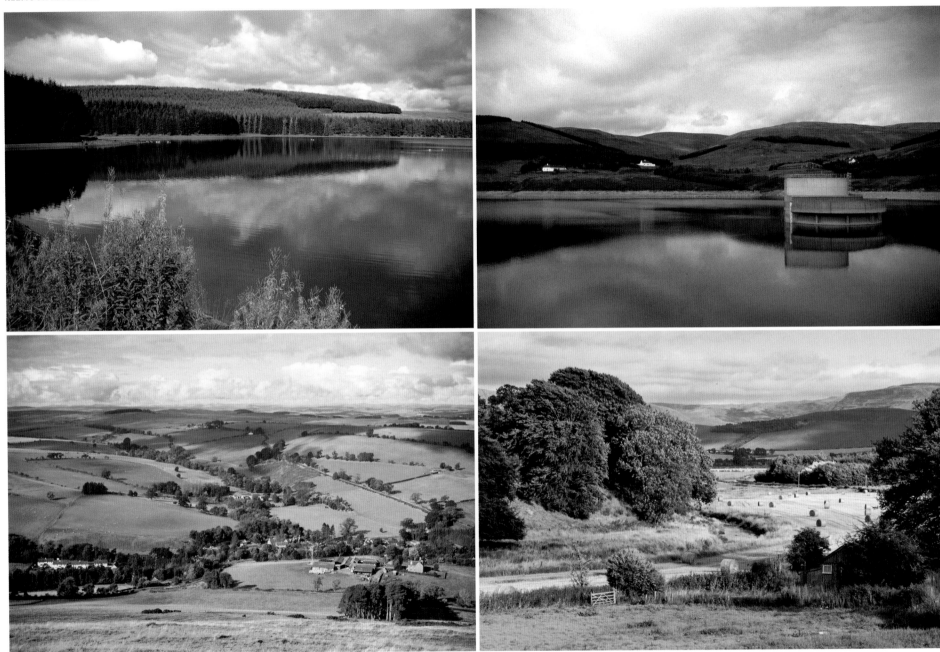

48

RULE VALLEY. BONCHESTER BRIDGE

KALE WATER

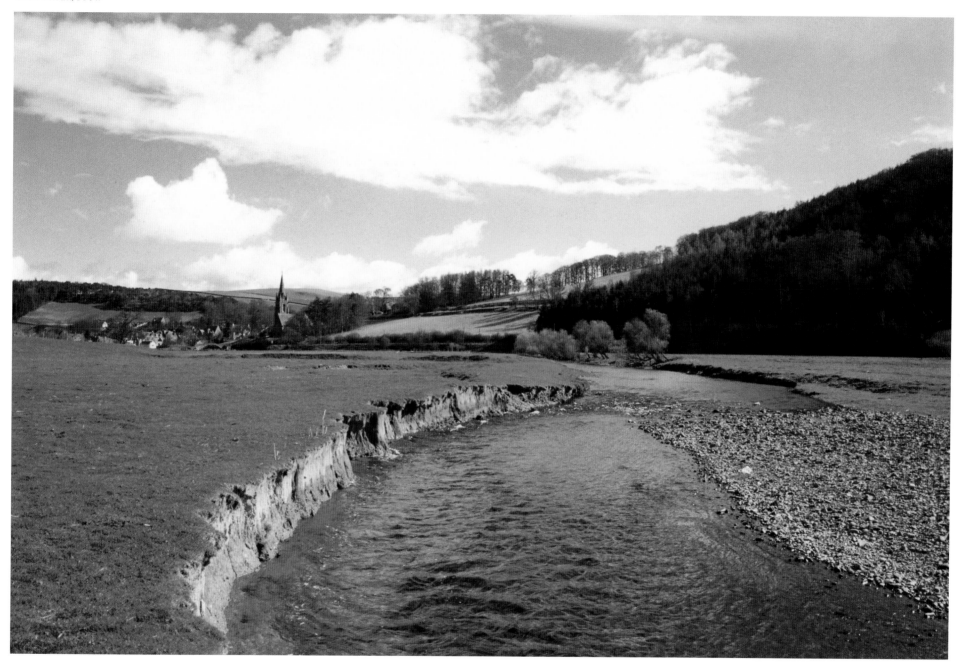

BLACKADDER, NEAR FOGO

WHITEADDER, ABBEY ST. BATHANS

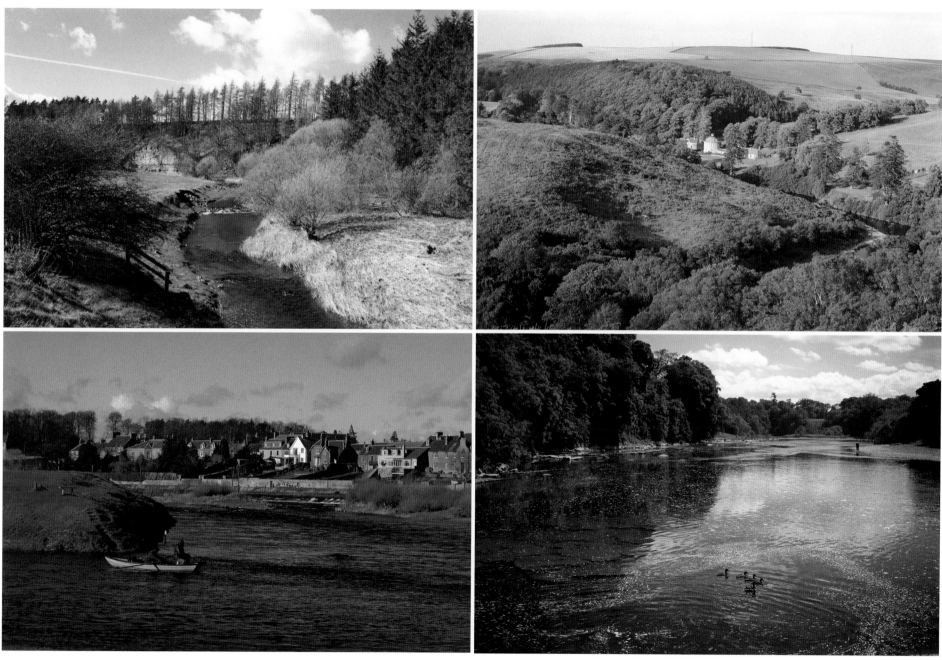

JUNCTION POOL, KELSO

RIVER TWEED, DRYBURGH

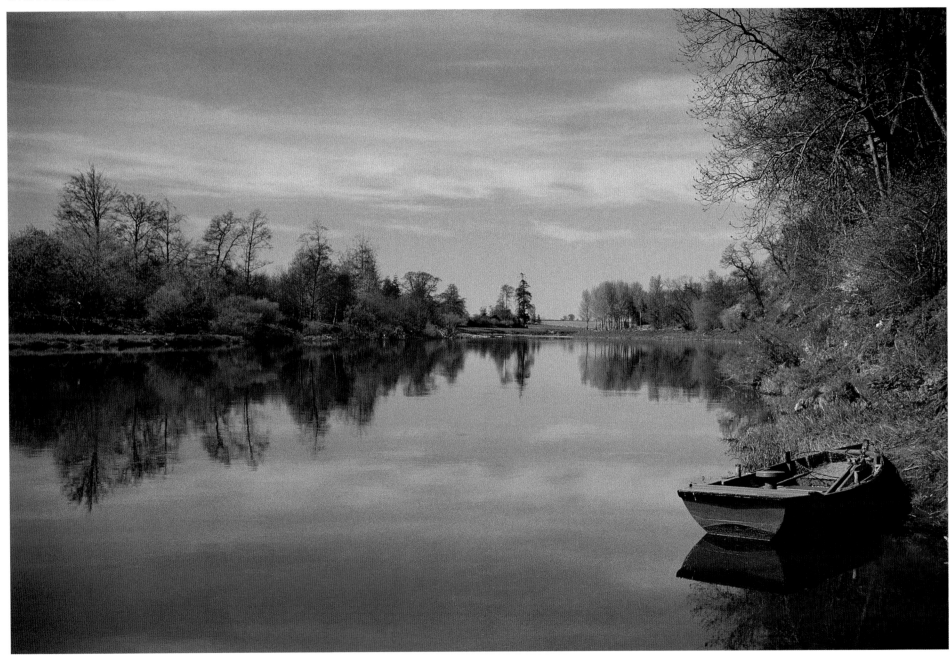

52

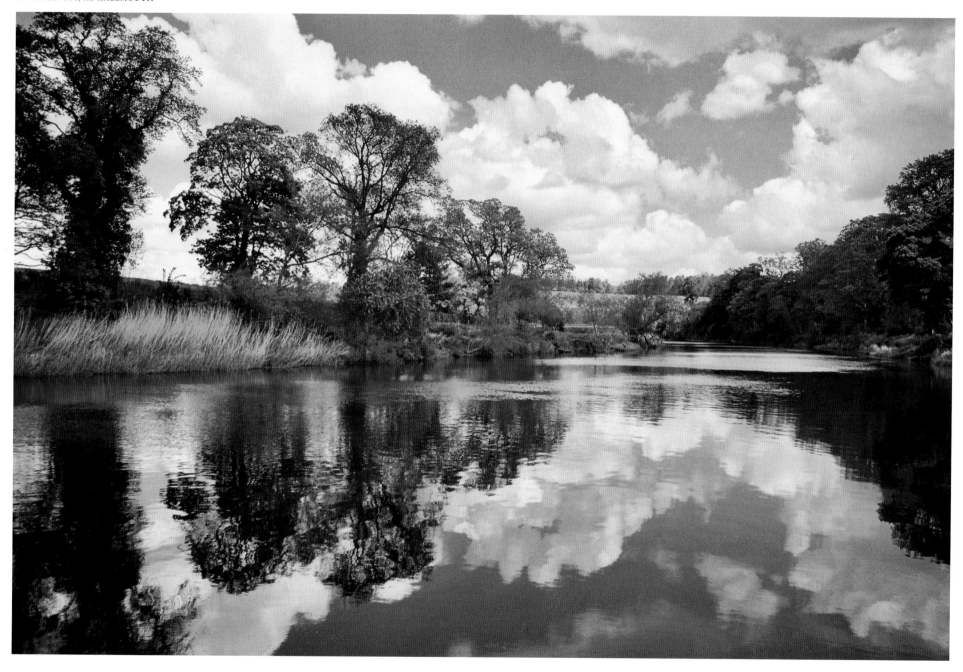

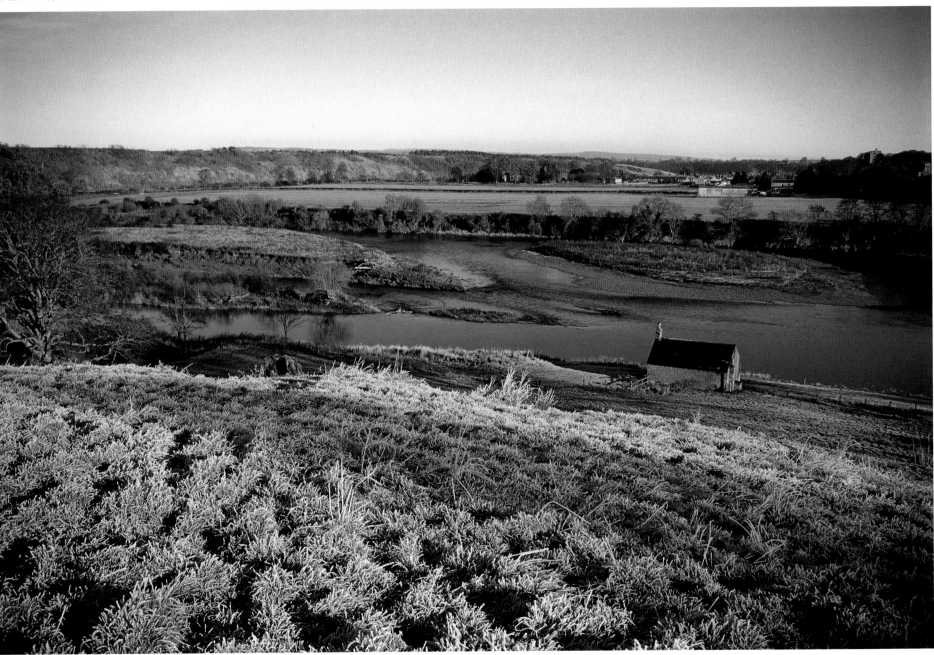

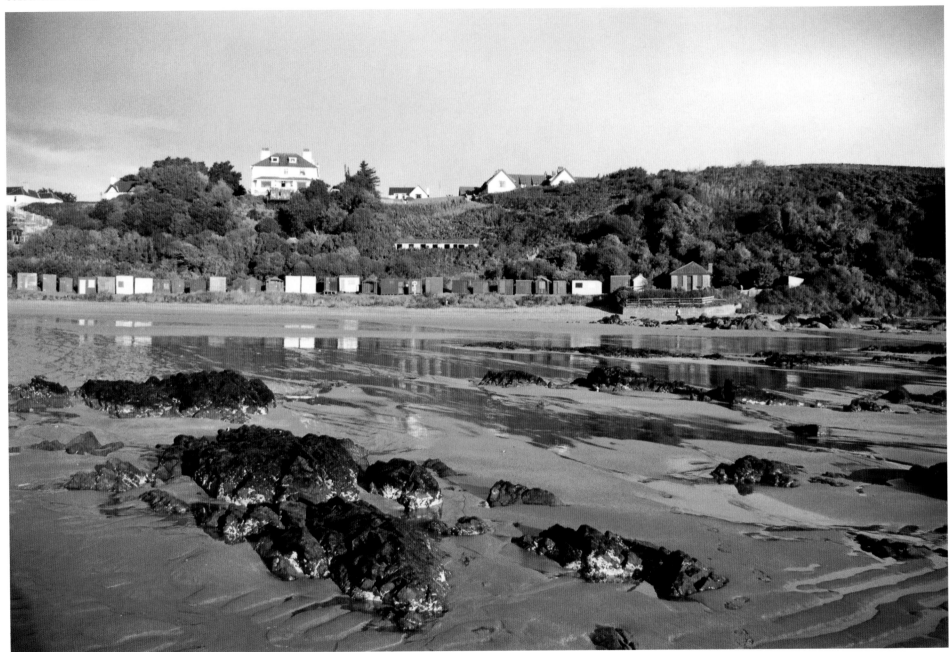

seem impervious to all that happens around them, stubborn and defiant. At the Duddo Stones it is impossible to feel anything other than a close affinity for the nameless people who dragged them overland and toiled to set them upright, forever.

The great revolution of farming was accelerated by the introduction of metal-working in the third millennium BC. Once again the process of adoption is mired in uncertainty, but its impact was immense. Metal could be worked when heated, it was tough and could cut and contain better than stone or clay. Technology advanced rapidly and the organisation of society no doubt reflected that. The Borders landscape was patterned with small farmsteads surrounded by an infield and outfield arrangement. The weather was warmer and drier between 3,000BC and 1,000BC and cultivation was possible on higher altitudes than it is now. Corn ripened up in the ranges of the Cheviots and

Lammermuirs, and the clearance of the ground continued apace.

But towards the close of the second millennium BC, life became insecure. Perhaps it was pressure of land that drove farmers to plough the hillsides, and perhaps that led to conflict. Defended settlements began to appear and in the Borders hundreds of hillforts were built, more than anywhere else in Scotland. Their sites seem to follow the river-systems rather than seek out good, defensible places in the higher ground. That suggests a close relationship with a hinterland of pasture and fields, and the people who worked them. In that context it is difficult to resist the notion of a strong warrior-chief occupying a fort and offering protection and refuge in return for a tax in farming produce. The perimeters of many of the forts appear to require too many men to defend them like a rampart, and they may have been corrals to keep valuable beasts in one place while the

fighting, or negotiation, went on in the open [or at least in some sort of limited way like skirmishing or possibly single combat.]

By far the largest hillfort in Scotland was raised on the summit of Eildon Hill North. A huge settlement of 300 hut platforms was laid out, with room for 200 more, on a 39-acre site inside a ditched perimeter skirting the summit for more than a mile. It may occasionally have held a population of 2,000 to 3,000, the equivalent of the modern town of Melrose lying at its foot.

With more than a mile of ramparts and ditches to defend, and no less than five entrances, it is highly unlikely that Eildon Hill was in fact a fort. It was probably a temple, a sacred precinct delineated by the long perimeter still clearly discernible around its summit. By the time of the first millennium BC the Borders was a Celtic society, speaking a form of early Welsh, and worshipping in a similar way to other

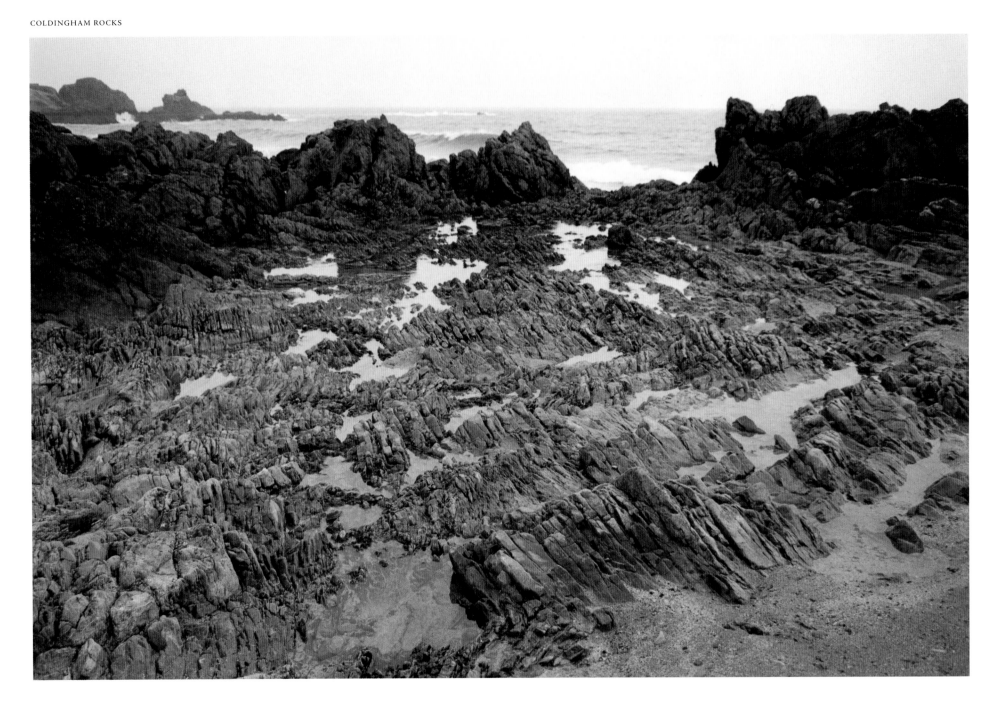

neighbouring Celtic societies. Four times a year fire festivals were held, usually on high places (Tinto Hill in Lanarkshire means *Fire Hill*) and these were led by a priest-king. By the time of the first millennium his people were known as the *Guotodin*, whom the Romans called the *Votadini* and still later became the *Gododdin*. The name may translate as *the people of the broad places*, meaning the Tweed Valley, and also the Lothians. The dates of the ancient festival were related to turning points in the stock-rearing year and they are recalled in the annual Beltane celebrations in Peebles and the old dates of St Boswells Fair and Kelso Show.

The Guotodin were not alone in the Borders. To the west lay the land of the *Selgovae*, whose name translates as *the Hunters*. This territory comprised hill country, was wilder, has many fewer prehistoric monuments and through time became the great royal hunting reserve known as the Ettrick Forest. The Selgovae were so called because hunting and gathering never left their repertoire of food production skills. Their territory was, in any case, ill suited to arable farming and their livelihood may have been largely sustained by stock-rearing. Later sources make it clear that the Selgovae and the Guotodin were not on friendly terms, and that ancient faultline between hillmen and plainsmen, between shepherd and ploughman, between country and town is one which still raises its head in the modern Border country.

What these peoples believed in was certainly less mysterious. Although they were anxious to climb up to be closer to their sky-gods on Eildon Hill North, they also believed in an Otherworld whose portals lay in the watery places of the Earth. Often they propitiated their fierce gods by sacrificing valuable objects and throwing or placing them in lochs, rivers, bogs or wells. A very beautiful bronze collar was found near Stichill and three intricately worked ceremonial shields discovered at Yetholm. Perhaps the most famous echo of this Celtic habit of throwing away metalwork lies in the story of Sir Bedivere taking the dying King Arthur's sword, Excalibur, to a lakeside where he hurled it into the water – and where it was caught by the Lady of the Lake.

Horses gallop into Border history in the first millennium BC, although they were probably present long before. The metal components of horse harness have been found and the tough little ponies which became so prized in the historic period were first yoked to chariots and driven into battle. Several equestrian traditions began at this time. Modern horses have their tails and manes plaited when being shown or competed, but it was Border charioteers who began to do this for quite practical reasons. Tails were bound up so that they did not foul the harness or yoke, and manes plaited to avoid the risk of becoming tangled in the long reins.

60

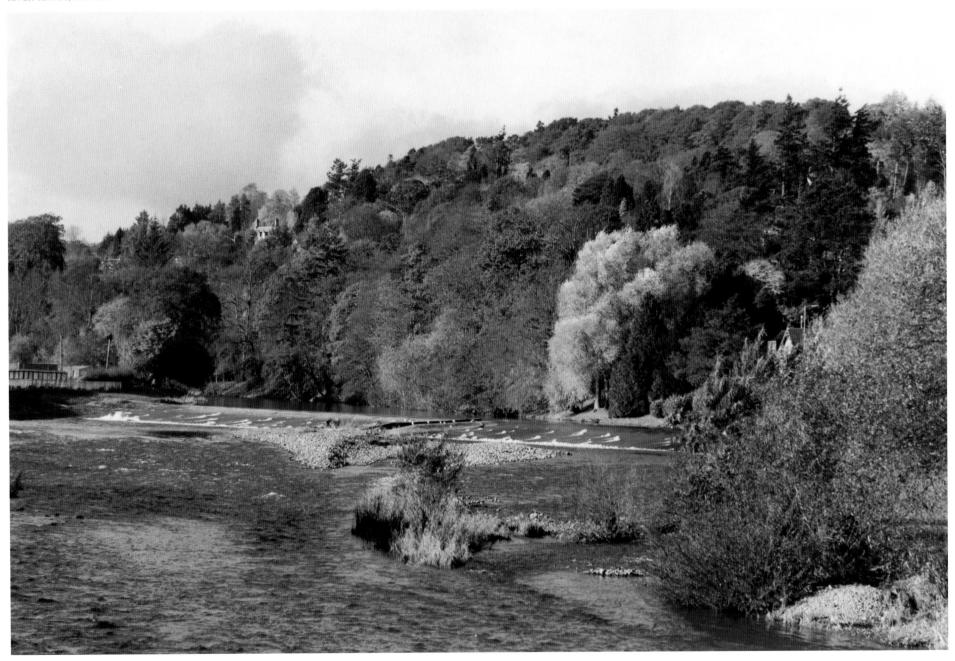

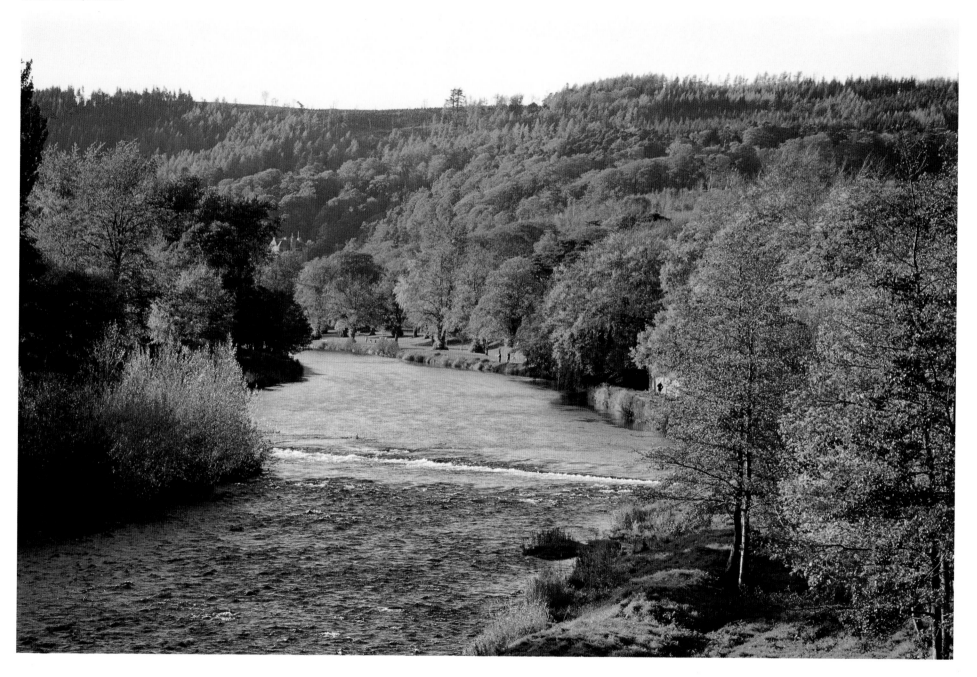

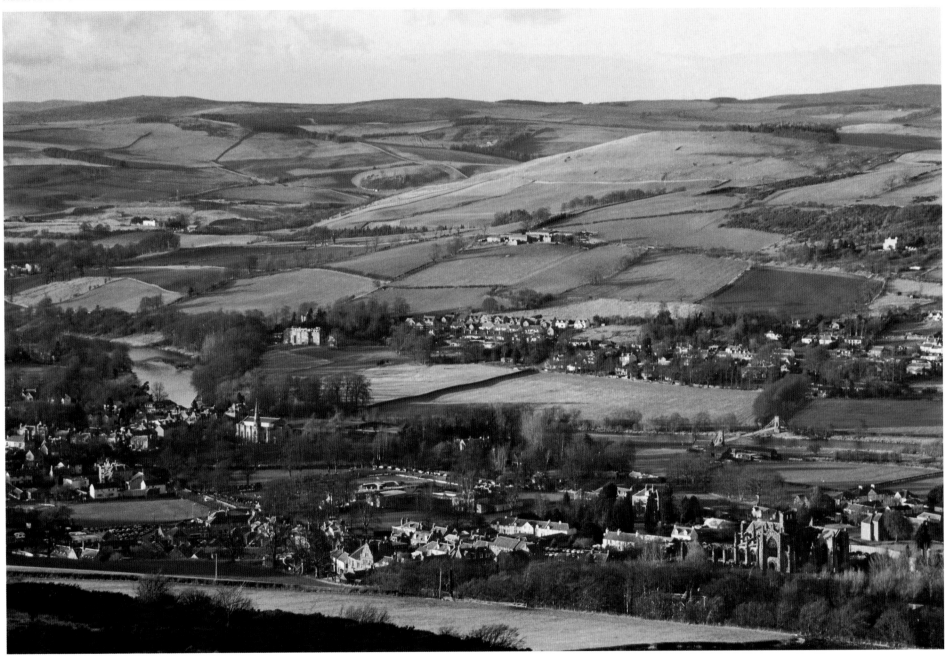

62

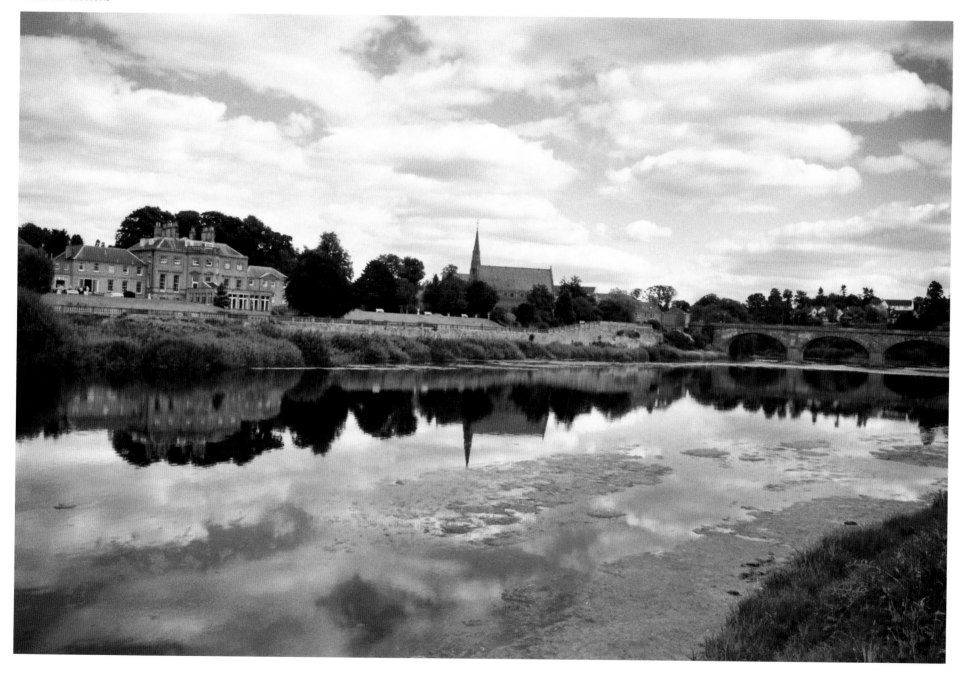

By the close of the first millennium BC the Border landscape had changed radically. The wildwood had disappeared, the original tree cover surviving only in places where cultivation or grazing was difficult – ravines, wet places and steep-sided valleys. Several species of native animals had been hunted to extinction; the great aurochs no longer rumbled through the forest and the lynx did not prowl the hills. Major routeways had been established and, marked by ditches and banks, long divisions created between groups of people. The Catrail is very old and it extends from Torwoodlee, north of Galashiels, southwards to well below Hawick. Perhaps it kept the Selgovae and the Guotodin apart.

◆ ◆ ◆

In the spring of 79AD lookouts on Eildon Hill North saw a remarkable but not unexpected sight. Snaking through the landscape a Roman army was marching towards them. Led by the Governor of the province of Britannia, Gnaeus Julius Agricola, the legionaries stopped at Newstead near Melrose and immediately began digging out the ramparts of a marching camp. After the three Eildon Hills, they called it *Trimontium* and garrisoned it off and on for 150 years. Before the Roman army tramped across the Cheviot Hills, on what became Dere Street, it had done a deal. It appears that the Guotodin had been bought off in some way, for no resistance seems to have been offered. By contrast the Selgovae remained implacable and over the 400-year history of the Roman province of Britannia, they were frequently in alliance with the Picts, occasionally foraying further south and fighting their way over Hadrian's Wall. In 105AD the Selgovan king led an attack on the fort at Newstead, routed the depleted garrison and burned down what must have been a hated symbol of the Empire. Roman military planners must have regretted transfering some of their British troops to Dacia (modern Romania) and allowing the Selgovae to exploit a moment of weakness.

Other Borderers saw the fort at Newstead as an opportunity. Local suppliers sold food to the soldiers, what was known as Celtic beer, and negotiated with the quartermasters on other goods. Outside the fort a civilian settlement, a vicus, grew up and no doubt all sorts of amenities were available. But the attitudes of the Romans were the same as colonists down the ages. They thought of the local Borderers as *the wogs*, and in Latin wrote of them as *Brittunculi* or *nasty little Brits*. However there is some evidence that they admired the Borderers' skills as cavalry troopers, and as they did elsewhere in Europe, they recruited them into the ranks of the Roman army.

By 212AD the Romans had abandoned their

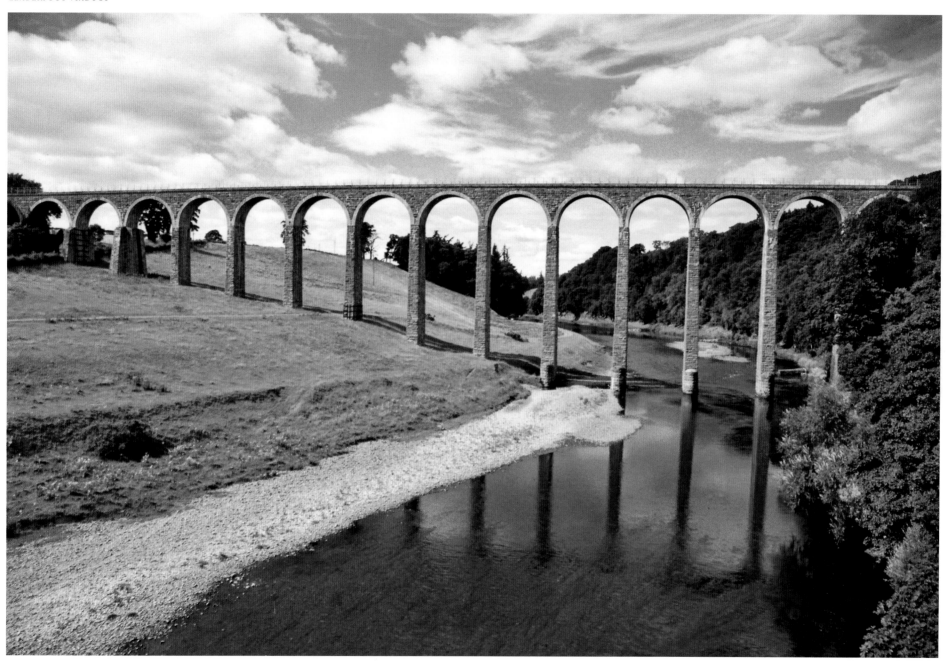

occupation of the Borders and retreated behind Hadrian's Wall. And two centuries later they quit Britain entirely as barbarian armies pressed hard on Rome itself.

The old Celtic kingdoms of the south of Scotland re-emerged and the Guotodin transformed themselves into the Gododdin. With great fortresses on Edinburgh's castle rock, at Traprain Law in East Lothian, and control of the temple on Eildon Hill North, their kings had power over the Lothians, the Borders and north Northumberland. After the end of the Empire in Britain little is heard of the Selgovae and their vaunted name vanishes from the map of history. But the identity of their ancient hunting ground has persisted in the Ettrick Forest.

The modern Celtic culture of the north and west of Scotland is expressed in Gaelic, essentially an imported dialect of Irish Gaelic. But when the adjective *Celtic* is attached to the Borders during the period known as the Dark Ages, it means something different. Before and after the 400 years of the Roman colony of Britannia, the British spoke an early version of the Welsh language. From Caithness to Cornwall dialects of this speech described the landscape. And all over the Borders lie the remains of Welsh place-names; Kelso means *Chalkhill*, Peebles *the place of the tents*, the landmark hills of Ettrick Pen and Lee Pen contain the Welsh word for *head*, and many of the farms of the western valleys have had the same addresses for more than 2,000 years.

The old Welsh kingdoms of southern Scotland were powerful in post-Roman Britain. In the shadow of Hadrian's and the Antonine Walls, they had become willing buffers between Britannia and the restlessly warlike Picts of the north, developing a fearsome warrior aristocracy that rode into battle on horseback. Their most famous son was perhaps the most famous warrior the world has ever known. Strong, persuasive evidence suggests that Arthur, neither a legend nor a king, had his base in the Tweed Valley, what later became known as *Camelot*. The Welsh place-name for Roxburgh Castle, originally a huge Dark Ages stronghold standing at the confluence of Tweed and Teviot near Kelso, was *Marchidun*, and it translates as *the Cavalry Fort*.

Arthur's banners flew some time around 500AD, and amongst his enemies numbered the Picts, and the Germanic tribes who had begun to settle along the coasts of eastern Britain. At the rock of Bamburgh a nest of Anglian pirates established themselves, and within a generation they were expanding into Northumberland and the Tweed Basin. One of Arthur's successors, Urien King of Rheged, compiled a British coalition army to attack and expel the Anglians. In 590 they rode into enemy territory and launched themselves

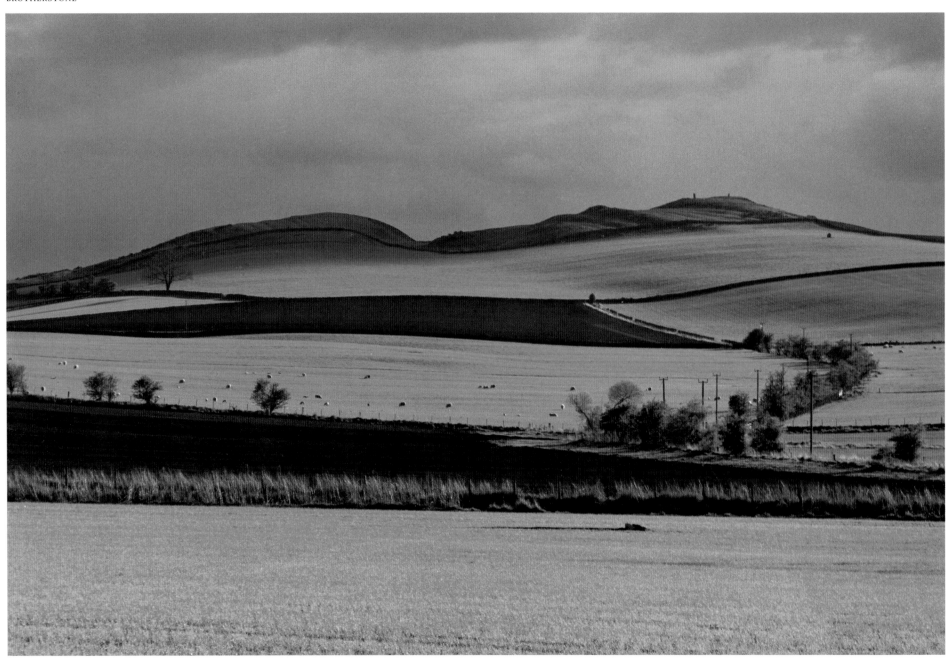

against the stockade at Bamburgh. At first the coalition enjoyed brilliant success, installing their Irish allies in the Anglian castle and bottling up their remnants on the island of Lindisfarne. Urien chose not to risk any more of his troopers and his host encamped on the mainland opposite to starve the Angles out and away into their ships. But at the moment of triumph, disaster struck hard. Out of jealousy, wrote the chroniclers, Morcant, a British prince who may have ruled on the Tweed, had Urien murdered in his tent. The alliance immediately disintegrated, the Anglians escaped from their island prison and the whole history of Britain turned decisively in a different direction.

By the 630s Anglian warbands were foraying far up the Tweed. One was led by a captain called *Hroc*, the *Rook*, and when he attacked and seized the old Arthurian fortress at Marchidun, he had it re-named after himself. The castle became *Hroc's burh*, the *stronghold of Hroc*, now rubbed smooth by time into Roxburgh.

The warbands brought more than fire and sword to the Tweed Valley, they also introduced the English language, the speech of the ruling elite. It took many centuries, perhaps five or six, for this Germanic tongue to displace native Welsh, but by the early middle ages, its triumph was complete. Border Scots is the lineal descendant of the guttural language spoken by the warbands and its oldest and richest variant is still uttered in Hawick. Basic words (like *yow* for you, *mei* for me, *throwe* for through and many others) are pronounced radically differently and may hark back to much earlier forms.

The Angles also bestowed many place-names, such as *Hawick (Hedge-farm)*, *Berwick (Barley-farm)*, *Jedburgh (Stronghold on the Jed) Selkirk (Hall-church)* and many others. And they moulded the shapes of those places.

Midlem (*Middleham* or *Middle Village*) retains its central green with houses fronting it and long back gardens and field plots stretching back behind. Villages like Midlem, Ancrum and Denholm sit in the midst of the homely geometry of fertile fields, hedges, shelter belts and steadings, and sometimes they prompt a comment about how much more like parts of England the Tweed Valley looks. But the historical truth is that it is a mixture, a unique mixture.

Just as the place-names are the deposit of an early cultural synthesis between Celtic and Germanic culture, so the sort of Christianity that developed in the Borders exhibits a similar duality. Stemming first from Carlisle, which endured as a working, walled Roman town well into the seventh century, the word of God crept westwards, up over the watershed hills and down into the Tweed Valley, leaving very early churches in the Manor Valley and at Peebles. Celtic styles of devotion

came to Melrose in 651 when the Anglian kings sent to Iona for priests to organise their church. Aidan came and was an illustrious founder of the hermetic monastery at Old Melrose, a place set apart from the temporal world, nestled in a bend of the Tweed below Bemersyde Hill. Like the henges and the sacred perimeter on Eildon Hill North, Old Melrose was marked off by a ditch and a palisade set on the upcast. Behind it the monks tried to live a pious life in imitation of their Lord Jesus Christ, spending long hours in prayer and mortification of the flesh. A leathery old priest, Drythelm, was fond of standing up to his neck in the ice-cold winter waters of the Tweed while reciting scripture and dedicating his miserable earthly body to the service of the Lord. When asked how he could bear such bitter cold, the old monk shook his head. *Aye*, he said, *I've known it colder*. That is probably the earliest historical example of the dry, hard-bitten humour of the Borders, the sort of grim comment old men might exchange as they struggle through a swirl of snowflakes in the Market Place in Duns.

Old Melrose was not Aidan's only creation, but his saintliness made it famous and inspired some young Borderers to take holy orders. Welcomed by the unctuous St Boisil (who gave his name to St Boswells), Cuthbert came to the monastery in the loop of the Tweed to begin his exemplary life. When he succeeded to the bishopric of Lindisfarne, the most powerful ecclesiastical office in Britain, Cuthbert found himself part of the ruling elite of Northumbria, one of the most influential men in all Britain. With justice, the kings who governed from the rock at Bamburgh could claim to be *Bretwaldas* or *Britain-rulers*, with the power of overlordship running as far south as the Kentish coast. The Borders were not peripheral but part of the beating heart of the ancient kingdom of Northumbria, a polity which was neither English nor Scottish, (these adjectives were in any case well ahead of their time in the 8th century) but a fusion of Celtic and Germanic ideas and habits.

Dragons fly the night air and portents are seen over the sea, wrote the monastic chroniclers in the year 793. The Vikings had appeared off the shores of Northumbria, as it were, out of nowhere, and they attacked the defenceless monastery of Lindisfarne. Cuthbert's sacred bones were removed inland to safety and began a long peregrination around the Tweed Valley and the north of England before being finally laid to rest at Durham. In another loop in another river, the great cathedral was ultimately raised there, and such was the magnetic reputation of Cuthbert, it grew into the richest church in Britain. And such was the prestige of the saint from the Borders that his presence in the south supplied an early definition of Englishness.

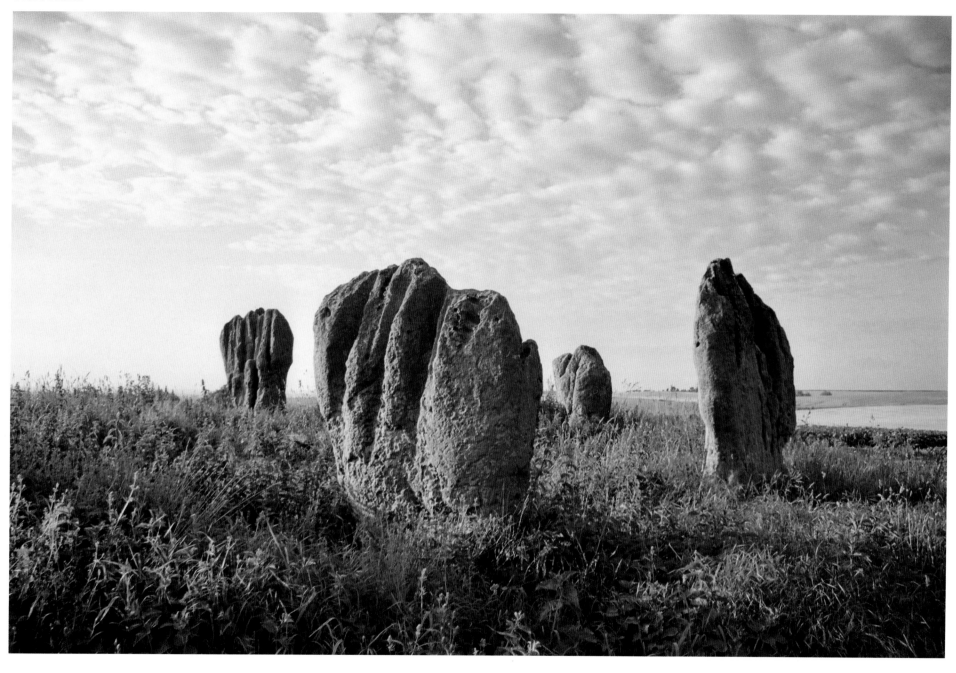

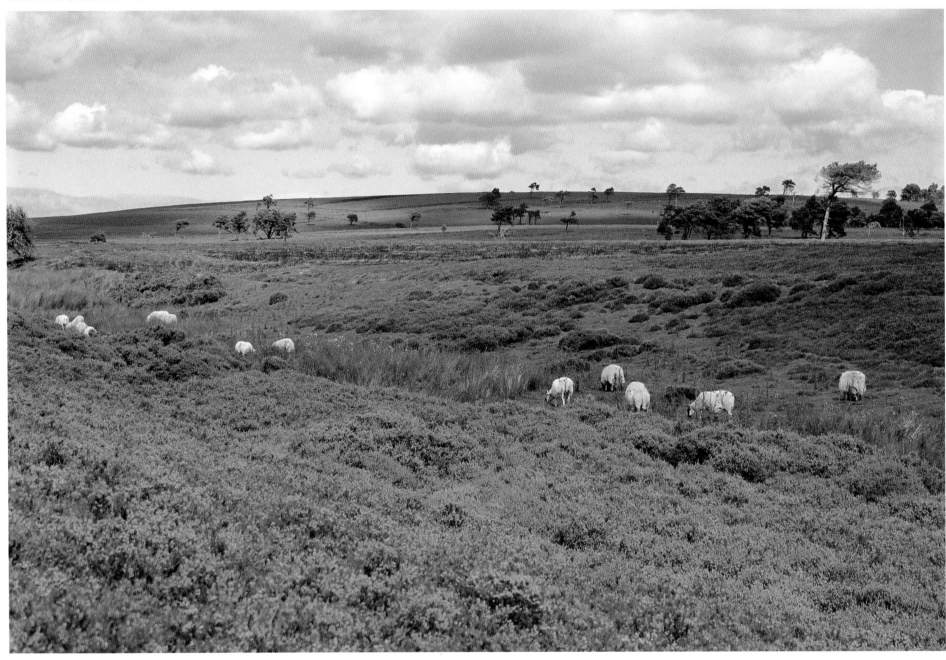

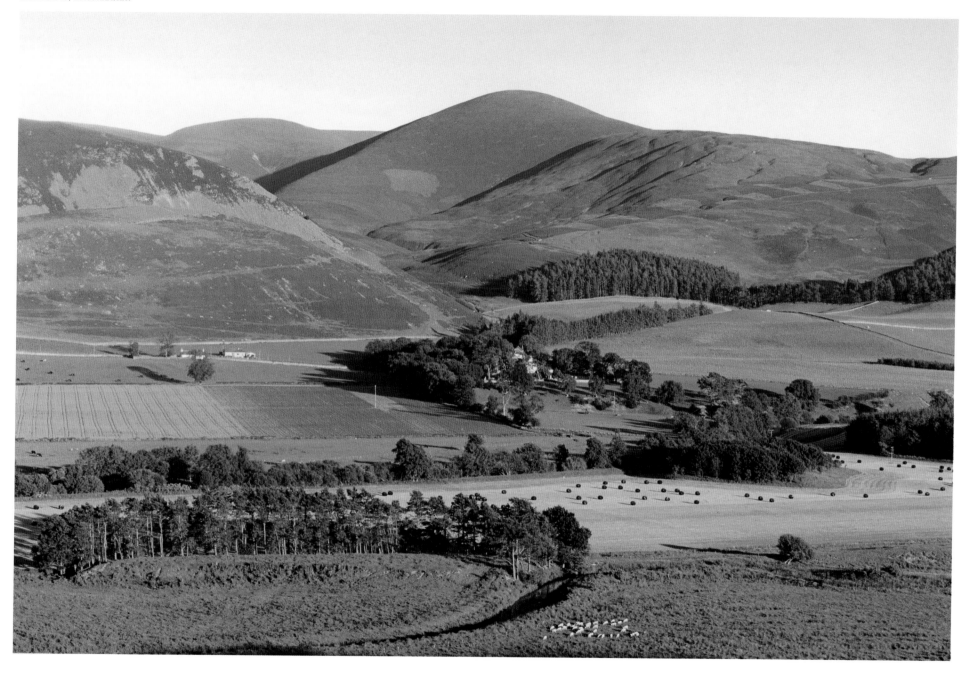

76

BALES, BERWICKSHIRE COAST

HAY MAKING

As the frontier between the expanding Gaelic kingdom of Scotland began to settle on the line of the Tweed in the east, those who lived to the south of it were not called the English, but instead the *Haliwerfolc,* or *the Holy Man's People.* Cuthbert was of course the Holy Man.

In 870 a large fleet of Viking dragonships was seen off the Berwickshire coast. In search of portable loot, they attacked the defenceless nunnery at Coldingham and burned it and all inside to the ground before advancing to raid inland. Under this sort of pressure from the Viking kingdoms and the waxing power of Wessex in the south, Northumbria began to crack and disintegrate. By the year 1000, the Gaelic dynasty in the north had laid claim to the Tweed Valley, and in a bloody battle at Carham in 1018, Malcolm II of Scotland ended 400 years of Northumbrian rule north of the great river. It is no historical accident that the border still runs where English blood flowed a thousand years ago.

• • •

The Borders had been a central and valuable part of the old kingdom of Northumbria but when the Gaelic dynasty of the MacMalcolms absorbed the Tweed Valley into their expanding Scotland, the place became peripheral. Power was focused in the north, in the Midland Valley, and the Borders very slowly became a buffer against the English, and for many centuries an extended battlefield zone. But not, however, before a golden age had dawned.

King Malcolm Canmore and his Queen, the saintly Margaret, were blessed with six sons. The youngest was David, born in 1084, and with five older brothers he can have entertained little thought of one day wearing a crown. But matters fell out differently. In 1107 Alexander I ascended the throne of Scotland and reluctantly passed on to David the earldom of the Border country. It was a very rich domain. In the west it compassed the old Welsh kingdom of Cumbria, not only the area bounded by the modern name, but also Annandale, Galloway and the hill country to the north. David also got Tweeddale and Teviotdale, and it was here that he began to make his distinctive mark.

Having been educated and raised at the court of King Henry I of England, the young man found himself at the centre of European culture. In particular he was very aware of the directions in which the church was developing, and appears himself to have been genuinely devout. In 1113, he followed his pious instincts and did something innovative and highly significant. From the Forest of Perche in northern France, David brought 13 monks of the reformed order of Tironensians to settle in a new daughter monastery at Selkirk. It was an inspired

78

SILEAGE, NEAR SKIRLING

POTATOES, MAKERSTOUN

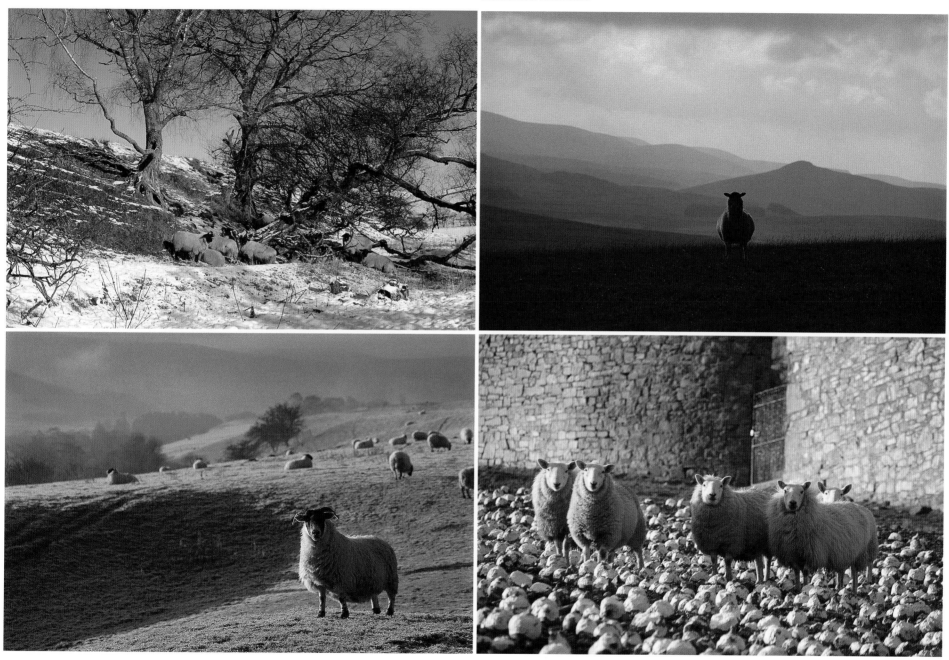

BLACKIE, FROSTY MORNING

TURNIP FIELD AT STOBO

idea which had a profound impact on the history of the Borders.

When he arranged gifts of lands and rights for the new foundation, the young earl was generous, and also very informative. His charter to the new abbey at Selkirk shines a brilliant early light on the landscape of the Borders. It was clearly a highly developed, fertile, busy and relatively heavily populated area. And no wonder that the MacMalcolm kings coveted what was then northern Northumbria. The charter contains the first historical references to Midlem, Bowden, Sprouston and many other places which must have been well established long before 1113. Two towns come on record. The fascinating, disappeared burgh of Roxburgh was the inland market and depot for a flourishing international trade in wool and hides. Farmers drove their herds and flocks to the town which lay between Teviot and Tweed where they join at Kelso, and there the

animals were killed and processed. Woolpacks of tightly bound fleeces were probably loaded onto barges waiting in the river, and then punted down to Berwick where they were re-loaded onto ships bound for the ports of Flanders and further afield.

By the standards of the day Roxburgh and Berwick were large towns, and the frequency with which Scottish kings held court in both underlines their importance. Most of their buildings were made of wood, had long backlands behind them where animals were kept and often the houses set their gable-ends to the street frontage. Suburbs sprawled beyond the walls and dangerous industries such as blacksmithing (sparks could and did ignite fires which burned down the whole burgh) were expelled, as was the noxious business of hide tanning which was done in pits filled with a concoction of dog turds, urine and other ingredients. Aside from very basic regulations like these, medieval

towns were haphazard, not pretty and when it rained must have become squelching quagmires.

The wool and leather trades created much in the medieval Border country. As business boomed, buildings were raised, the like of which had never been seen before. The most enduring monuments to the surge in the economy of the Borders are the four great abbeys at Kelso (formerly Selkirk), Melrose, Jedburgh and Dryburgh. They are magnificent. All built in the middle of the 12th century, three were founded directly by David I and the fourth, at Dryburgh, by a wealthy subject. In the porch at Kelso Abbey lie two tombstones rescued from the vanished town of Roxburgh, and they witness the reason why the great churches rose in the landscape. Their inscriptions are to two wool merchants, and their acumen for business allowed the monks to build high and grand, and to sing, chant and pray in the worship of God.

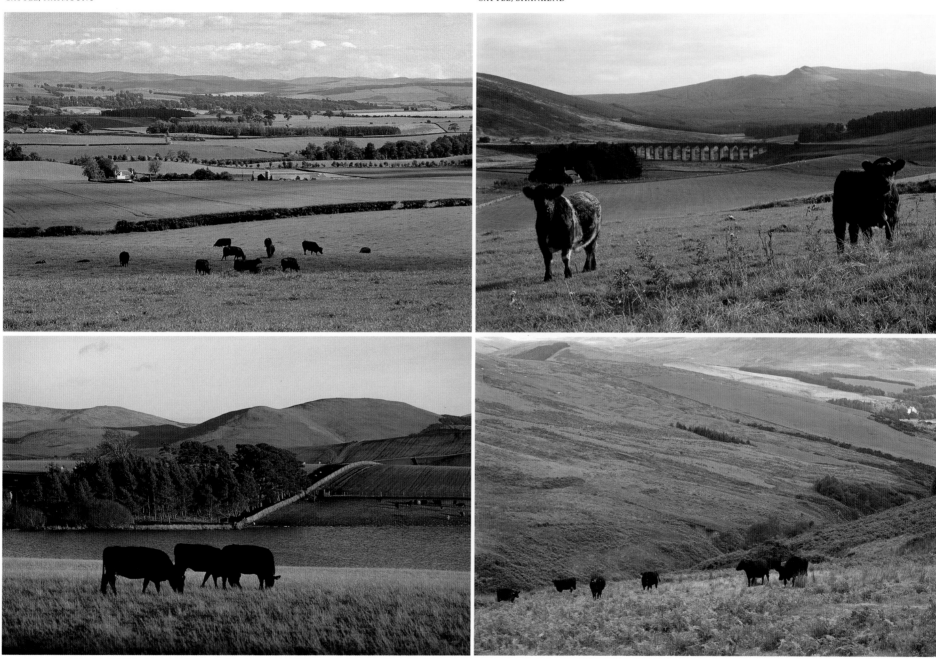

GRAZING AT HOSELAW LOCH

HILL CATTLE, SORBIE, ESKDALE

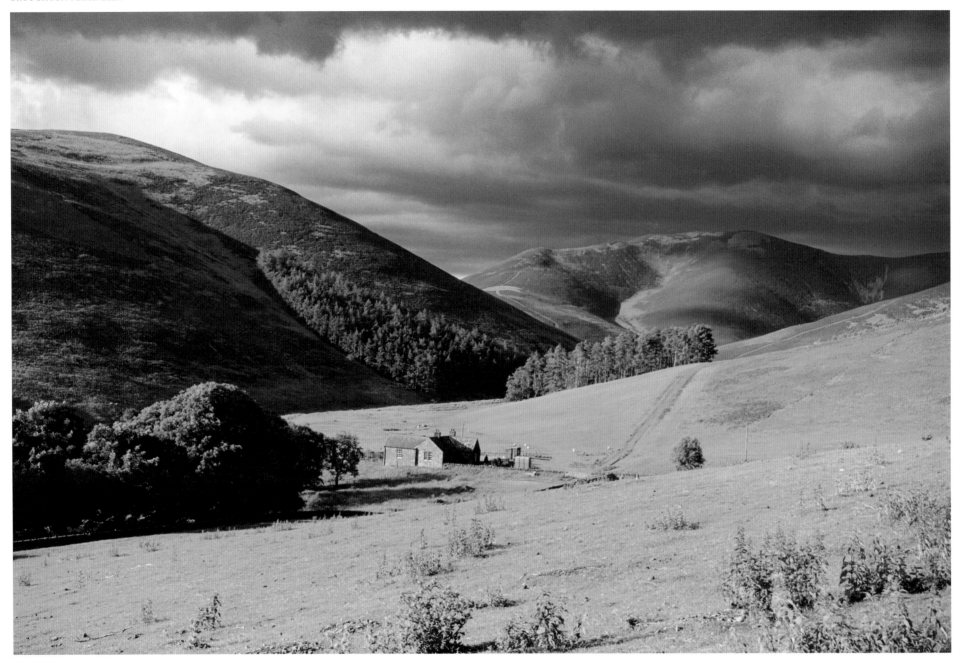

It should not be forgotten that these abbeys and many other lesser churches, chapels and nunneries were created out of simple piety. In this secular age we easily forget how central and absolute Christian faith was. When King David granted all that wealth to Melrose, Kelso and Jedburgh, he believed absolutely that his generosity would buy him a seat at God's right hand in the kingdom of Heaven. Noblemen sometimes endowed churches with conditional gifts. Towards the end of their sinful lives, they wanted the right to take holy orders at one of the abbeys so that when their time came, their chances of passing on to glory were greatly enhanced. It was counted a merciful deliverance to gain the monkish privilege of being buried inside the precincts of the abbeys. It was the holy of holies. Just as on Eildon Hill North, looming over the great church, the walled precinct surrounding Melrose Abbey was a boundary between the secular and the sacred. And it was firmly believed that the burial ground inside (and especially inside the abbey church itself) contained magic soil which had the power to dissolve the earthly sins of a body interred in it.

The vibrant medieval economy also seems to have encouraged education. Two of the greatest European scholars of the age benefited from good early instruction in the Borders. John Duns Scotus came from the Berwickshire town and at the University of Paris, made a reputation as a technically brilliant philosopher, able to argue against the ideas of opponents with brio and destructive confidence. After his death, his detractors called Duns Scotus' supporters *the Dunces*, but only because they were thought to be too clever by half. Michael Scot has a magical reputation. More exotic than the man from Duns, he may have come from upper Tweeddale, and he certainly travelled in the Mediterranean, taught at the court of the Holy Roman Emperor at Palermo, and could apparently practise some of the darker arts of alchemy. But he really made his academic reputation as a translator from Arabic. This last was extremely important to the history and development of western philosophy. Much of the work of Aristotle and other Greek thinkers had been lost in the west and was preserved only in Arabic texts. By translating these into Latin, Michael Scot brought them back into the mainstream.

The glittering achievements of the 13th century were created on the initiative of an elite and the philosophy of Duns Scotus mattered not a jot to the working people who toiled daily in the fields. At that time agriculture was everyone's business – even the Italian and Flemish merchants who moored their ships at Berwick's quays and came to bargain at Roxburgh market. Most of those who worked on the land were not free. Not exactly slaves either, they were bonded to a

superior who allowed them to cultivate and husband on their own account, but also bound them to provide much for him, or it. Many Borderers worked for institutions, principally the great abbeys. They grew to be enormously wealthy as those anxious for salvation continued to endow them. Especially at Kelso and Melrose there was great emphasis on the wool trade, the cash it brought in and the huge sheep ranches in the hills which sustained all that splendour.

In 1300 the medieval population of the Borders probably numbered around 56,000, slightly more than half the modern figure. The numbers exclude the town of Berwick (which was about to become English) but they show a great density of settlement on the land. And in more intensively farmed arable areas of the lower Tweed Basin the density might have been as high as 50 per square mile. Compared with the modern countryside, medieval farms teemed with human activity. But even with the press of all these people the Borders was quiet and green seven centuries ago. The loudest artificial sound was the peal of the abbey bells ringing the canonical hours. No other mechanical noise could be regularly heard and the air was filled not with the whine and thrum of engines but with the distant bleat of ewes on a hillside and the cry of whaups wheeling in the updraughts. Given the number of people who worked the fields, there would often have been the chance of a blether, a laugh, the exchange of news, the telling of old stories. And at night, under the moon and stars the brightest light came from an open fire or a torch, or candle. When there was no moon or the cloud cover was thick, the countryside was black-dark, and no-one ventured outside willingly. Looking back to that time, the intensity and body-warmth of early medieval Border society must have been palpable.

In towns people lived even more cheek-by-jowl, but the scale of these settlements was small. If 10% of the population of Roxburghshire lived in towns then that leaves only 2,700 inhabitants between Roxburgh, Jedburgh and Melrose, to say nothing of other, lesser places like Kelso and Hawick. The largest town was certainly Roxburgh but a sensible allowance for other places leaves a population in the town of approximately 1,500 and 200 to 300 houses at the very most.

Each year the rhythm of the seasons in the Borders called for an ancient journey in the springtime which temporarily diluted that density of settlement. Known as *transhumance* it involved the driving of flocks and herds from lowland fields up to higher pasture for the summer. Since, literally, a time out of mind, communities had divided, and young men herded their flocks from what in the Highlands is still called 'the winter-town' up to the shielings of 'the spring-town' in the hills and moorland.

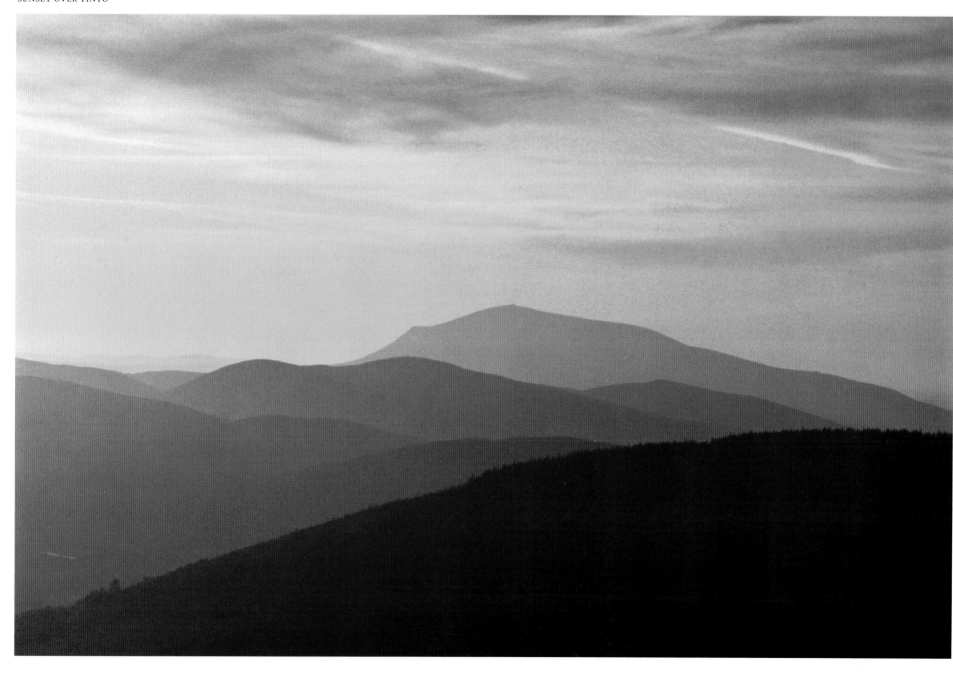

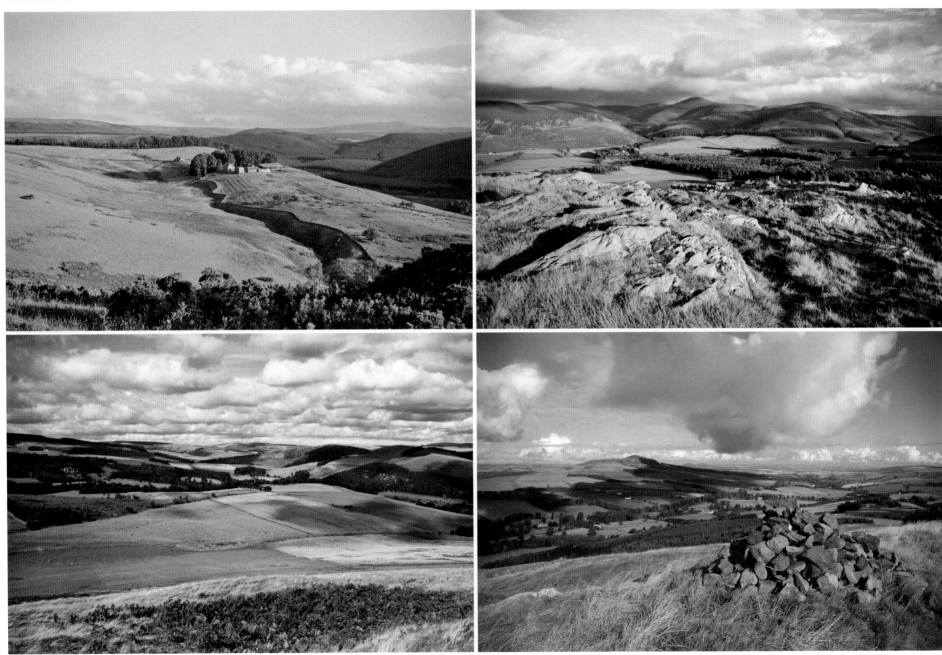

TORWOODLEE

BONCHESTER FORT

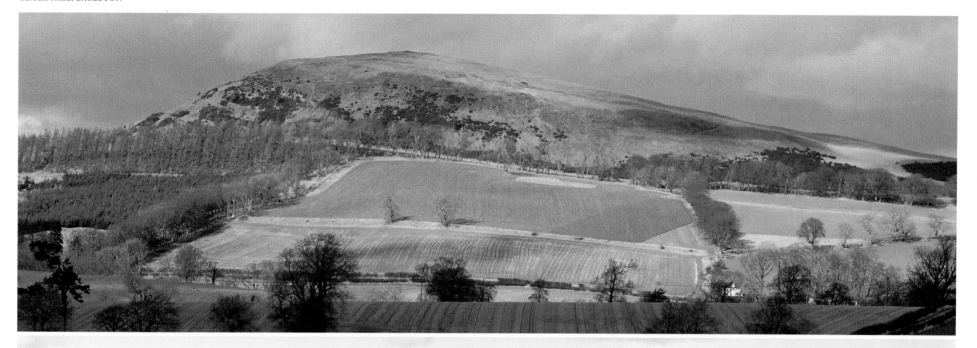

CADEMUIR RIDGE, MANOR

Many of the upland cultivation rigs still clearly visible in a morning or evening light were ploughed and planted by herd-laddies who stayed with their beasts long enough to harvest the oats and other crops. Not fenced or dyked in any way, the summer grazings were held in common right – as they still are at Selkirk and other Border burghs. The spring-towns were known as shielings in the Borders and the frequent presence of 'shiel' or 'shiels' in place-names remembers where some of them were. Galashiels is only the most famous.

Even though the herds had to be constantly wary, for wolf packs still hunted in the hills – Weststruther in Berwickshire means 'Wolf's stream' – there is a striking sense that the atmosphere around life at the shielings was different, less serious than in the winter-town. Living their lives outdoors, in the long and warm summer evenings, young people amused themselves with stories and music and echoes of the crack and laughter have come down to us in the shape of the Border Ballads. At the shielings these old tales were sung or recited around the crackle of a fire. Perhaps because it does not concern battles or cattle-raiders, or deeds of derring-do, the old ballad 'The Dowie Dens of Yarrow' carries some sense of the romance of the long evenings in the spring-towns of the Border hills. Here are some of the verses:

> At Dryhope lived a lady fair,
> The fairest flower in Yarrow,
> And she refused nine noble men
> For a servan' lad in Gala.

> Her father said that he should fight
> The nine lords all tomorrow,
> And that he that should the victor be
> Would get the Rose of Yarrow.

Not surprisingly the servant-lad was killed and his body flung into the Yarrow Water. His lover rode the hills looking for him;

> But she wandered east, so did she wast,
> And searched the forest thorough,
> Until she spied her ain true love,
> Lyin' deeply drowned in Yarrow.

She pulled him from the water and took his body back to Dryhope. Her father was not sympathetic and assured her that despite the death of her lover, she would wed well:

> Haud your ain tongue, my faither dear,
> I canna help my sorrow;
> A fairer flower ne'er sprang in May
> Than I hae lost in Yarrow.

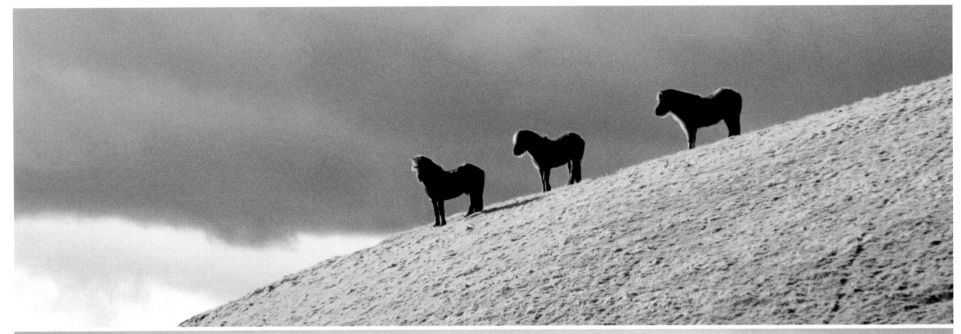

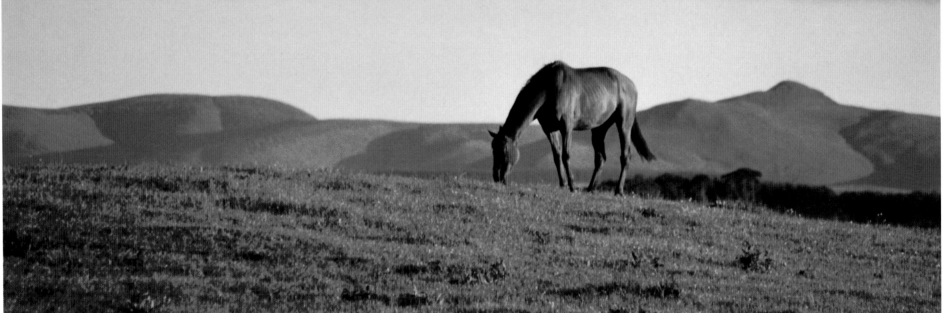

HORSE ABOVE HAWICK

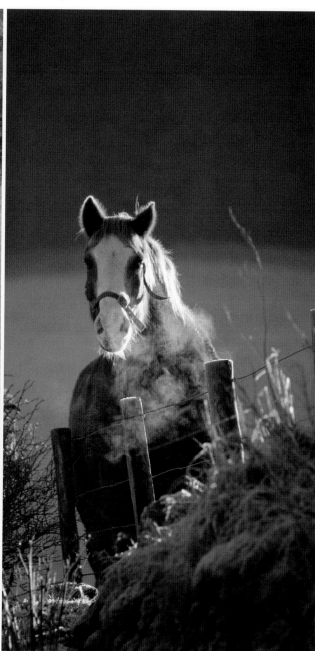

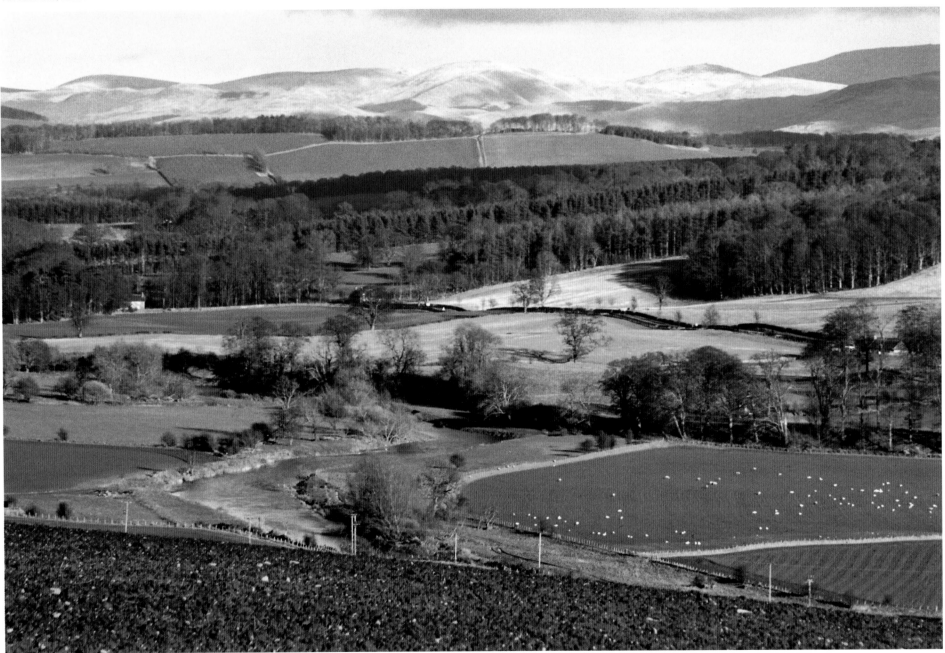

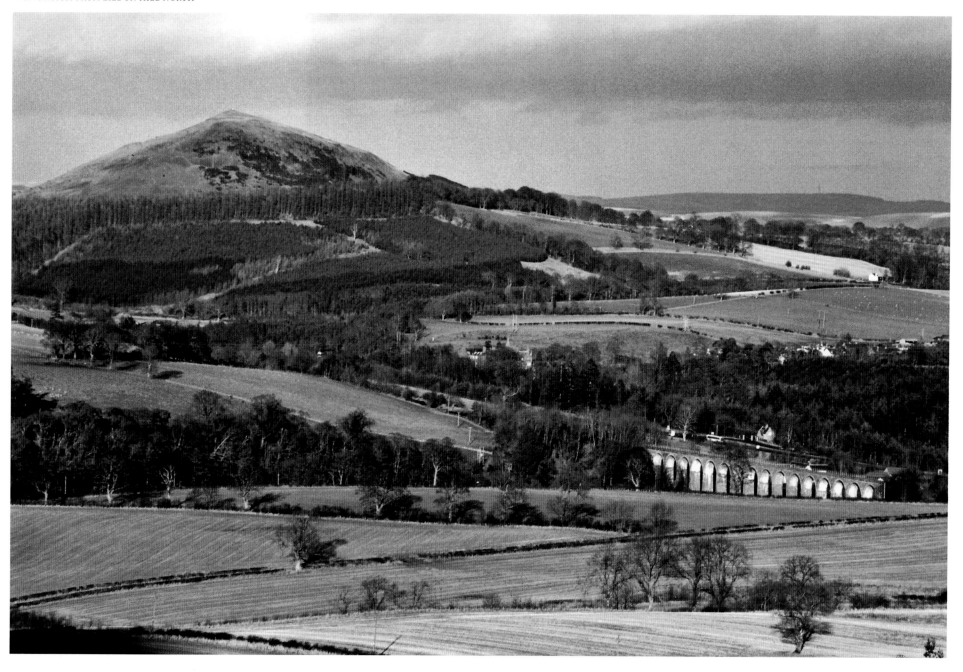

I meant to make my bed fu' wide,
But you may make it narrow,
For now I've nane to be my guide
But a deid man drowned in Yarrow.

And aye she screighed, and cried, Alas!
Till her heart did break wi' sorrow,
And sank into her faither's arms
'Mang the dowie dens o' Yarrow.

The geography of the Borders, with its river valleys and sheltering hills, is well suited to transhumance. In northern Berwickshire some parish boundaries include low-lying arable lands before looping up into the Lammermuirs to take in summer pasture. The annual journey from the winter-town could be long if a fermtoun was distant from its upland common and much gear had to be taken. Pack transport in the Middle Ages was mostly human with back-panniers made from willow withies, or even woven grass for cargoes such as grain. Ropes of spruce roots, twisted grasses or heather sat across the upper chest and secured panniers carried on the back. This was technology entirely unchanged from the time of the hunter-gatherer-fishers. Ponies were sometimes used to take heavier items slung across a wooden pack-saddle and the oxen needed to plough the high fields worked hard to pull sledges or solid-wheeled carts called ox-wains.

After lambing, the sheep were also driven up to the hill pastures to allow hay to grow on the lowland fields. Herds built low, turf-dyked enclosures for ewe-milking. These were the 'yowe-milkin' buchts' and they were used by young lasses who had walked up from the winter-town. Sheep's cheese was made from the rich and pungent milk, and no doubt before they made their way back in the light evenings, there was much *laughin'* and *daffin'* between the herd-laddies and the ewe-milkers.

Back in the winter-town those left behind kept the birds off the growing crops and made sure the milk cow's tether was fast in the ground. They spent time weatherproofing their houses. The 'Redd' or the 'redding up', as Borders dialect calls spring-cleaning, still goes on in many farms after the beasts are turned out for the summer. At harvest time some of the shepherds returned to the lowlands to make sure that all the corn was safely in, but August was too early to bring the flocks down off the hills. Depending on the weather, they could stay up at the shielings until late September. But when the year began to turn the young men gathered up their gear and drove the beasts back down to the winter-town.

Life was often hard for those who worked the land, famine occasionally gripped and, in general, conditions for ordinary people were little better than they had been

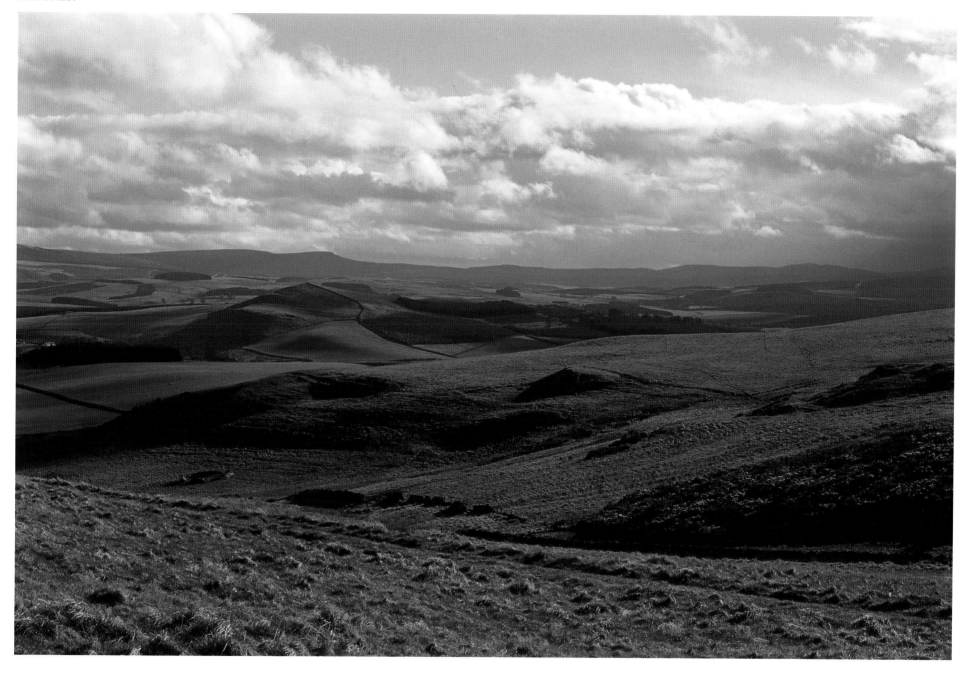

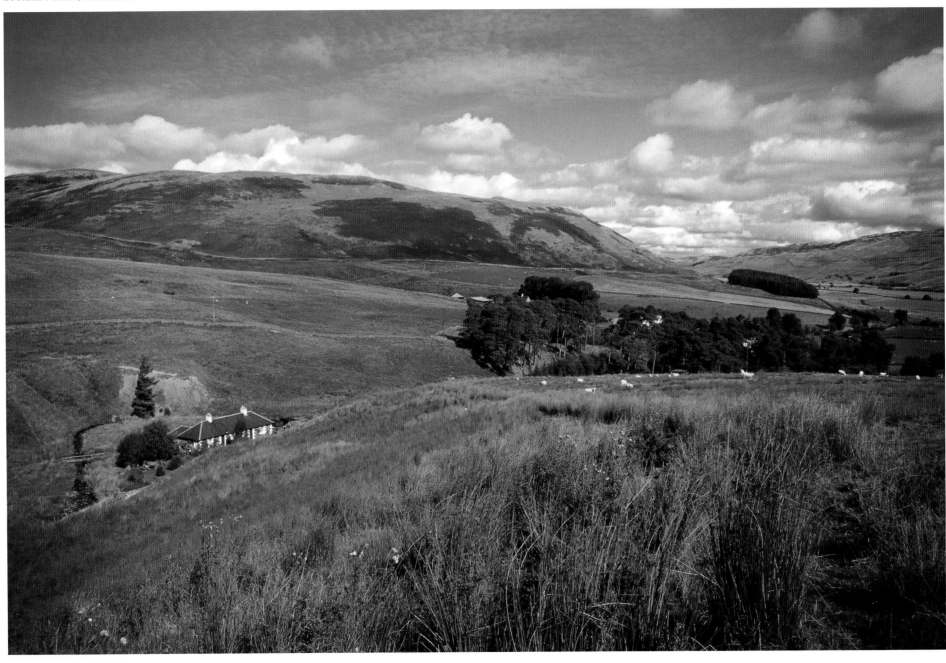

in prehistory. But it could be good, and was relatively stable. At least until 1286. In that year King Alexander III of Scotland was accidentally killed when his horse missed its footing on the cliff path above Kinghorn in Fife. He left no clear heir to the throne and the problems of the royal succession propelled Scotland, and the Borders in particular, into a protracted and highly destructive war with England. The golden age was about to give way to three centuries of intermittent warfare.

◆　　　◆　　　◆

Edward I of England coveted Scotland. In the 1280s he had colonised Wales, and with the death of Alexander III and no heir apparent, he determined to exploit to the full the opportunity that had fallen into his lap. At assemblies held in Norham church and Berwick Castle what became known as *The Great Cause* was heard in his presence. Many claimants to the throne of Scotland came forward but Edward of course chose someone he believed would be obedient to his will. But in the event, King John Baliol denied Edward and was humiliated and deposed by him. William Wallace took up what became a national cause and at Selkirk's Forest Kirk, he was proclaimed *Guardian of Scotland*. With his barbaric execution began the long struggle of Robert the Bruce to impose himself as king. The corrosive, blood-spattered wars that followed were often fought across the Border landscape, and all that had been built up by David I and his monks was thrown down and wasted. The border turned out to be very bad for the Borders.

The historical impression of an end to a golden age is not entirely metaphorical. The weather was indeed better between 1100 and 1300 and many summers will have been golden. Seemingly incessant rain, a succession of poor harvest and prolonged bouts of violent storminess ushered in what meteorologists have called The Little Ice Age. Beginning in the early 1300s and lasting, with significant breaks, until 1850, the weather worsened, average temperatures dropped and life on the land became very difficult. And what added to the misery of Border farmers was the regular tramp of armies across their fields. Between 1296 and 1513, the history of the Borders was dominated by the outcomes and effects of battles. Berwick was lost to England and for long periods the mighty castle and dwindling town of Roxburgh was held by an English garrison. And in 1349 even more catastrophe burst over the Borders. The terrible plague called *The Black Death* arrived, first erupting amongst an army mustering at Caddonlea near Galashiels. A third of the population died in agony.

By 1400 political and social instability had allowed the Douglas family to grasp their chance and become

powerful. They built a patrimony which covered much of the Borders. In addition to the Forests of Selkirk and Ettrick, they owned the old royal village of Sprouston, Browndean, Eskdale, Lauderdale and large estates in Teviotdale. In their slipstream their supporters also grew prosperous and powerful; the Humes became great barons in Berwickshire, the Hoppringles (later shortened to Pringle) were in Lauderdale and the Scotts and Kers in Teviotdale.

From this period Border ballads begin to survive. One of the very earliest was composed at the beginning of the 15th century and it tells the tale of a very famous Borderer, True Thomas or Thomas the Rhymer. In the service of the Earls of Dunbar at their castle at Earlston, he first made his reputation as a prophet at the end of the 13th century, as True Thomas. He predicted the death of Alexander III and many of the fell consequences that followed. Thomas was also a collector of stories and may have picked up a great deal from the dying Welsh language culture of the Borders. By 1300 the last speakers probably lived in the hills between the Leader and Gala Water valleys, near where Thomas lived. His prophecies were very influential at the time but are now mostly forgotten. But what has endured is the Ballad of Thomas the Rhymer and it may speak of the last glimmers of the evening of the old language.

True Thomas lay on Huntlie bank;
A ferlie he spied wi' his e'e;
And there he saw a lady bright
Come riding down by the Eildon Tree.

Her skirt was o' the grass-green silk
Her mantle o' the velvet fine;
At ilka tett o' her horse's mane,
Hung fifty siller bells and nine.

True Thomas he pu'd off his cap
And louted low down on his knee
'Hail to thee Mary, Queen of Heaven!
For thy peer on earth could never be.'

'O no, O no, Thomas' she said,
'That name does not belong to me;
I'm but the Queen o' fair Elfland,
That am hither come to visit thee.

'Harp and carp, Thomas' she said,
'Harp and carp along wi' me;
And if ye dare to kiss my lips,
Sure of your bodie I will be'

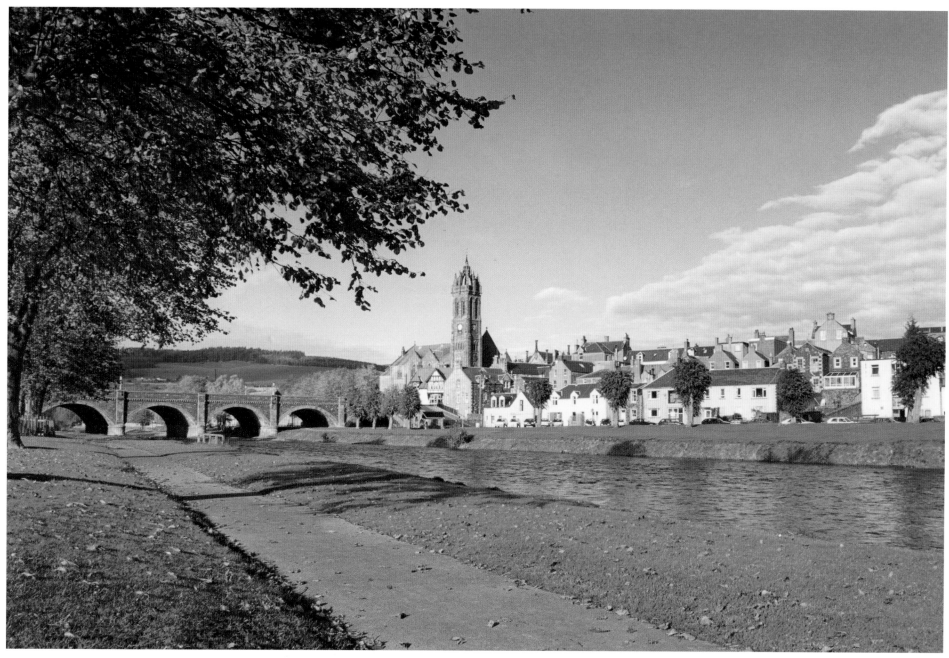

ROXBURGH CASTLE

ROXBURGH VILLAGE

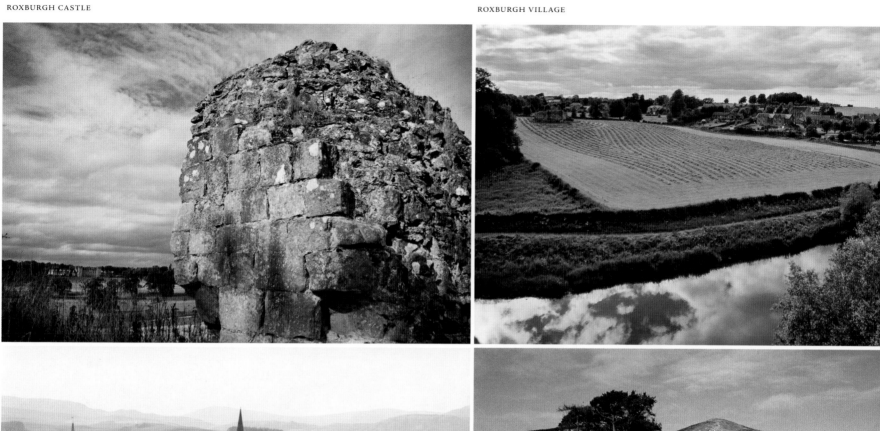

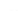

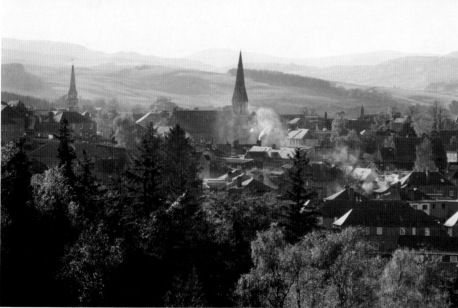

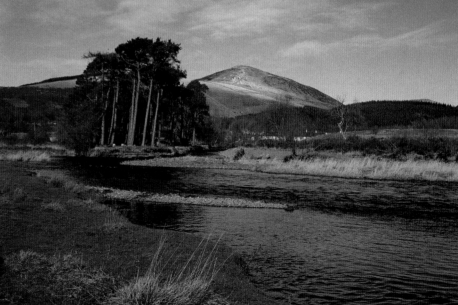

SELKIRK

LEE PEN, INNERLEITHEN

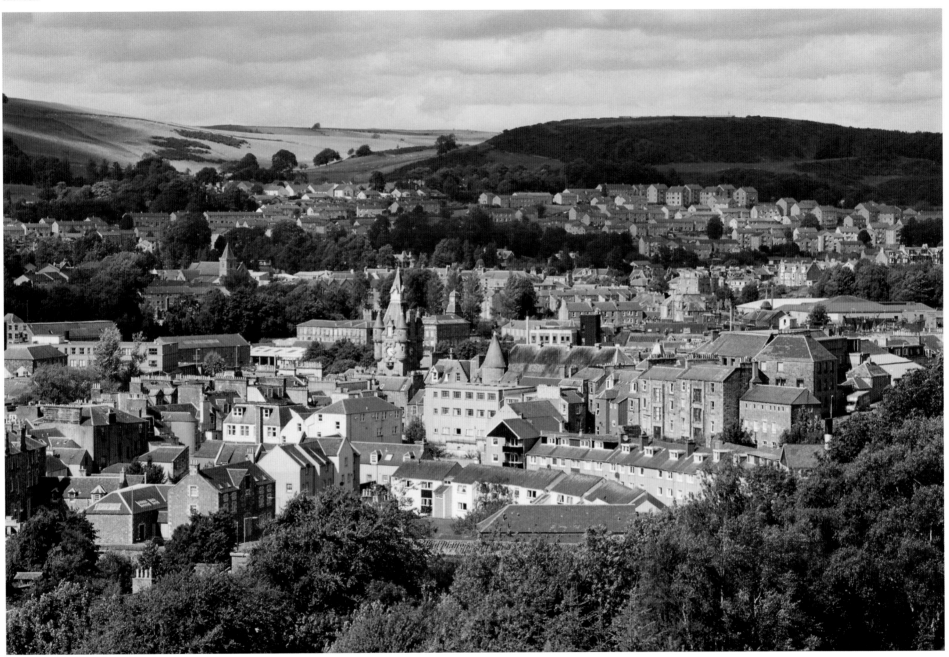

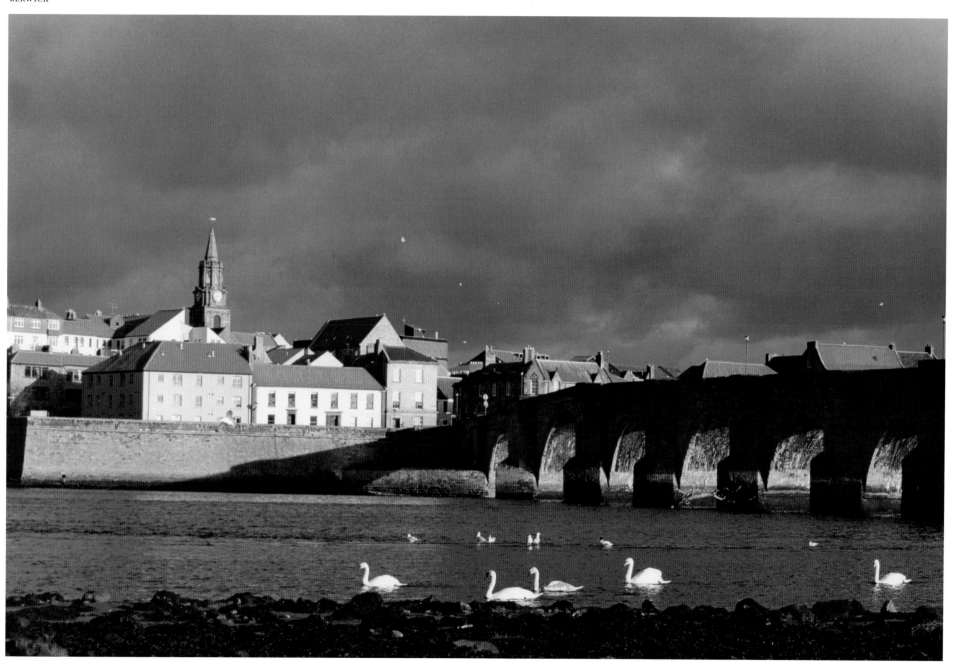
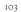

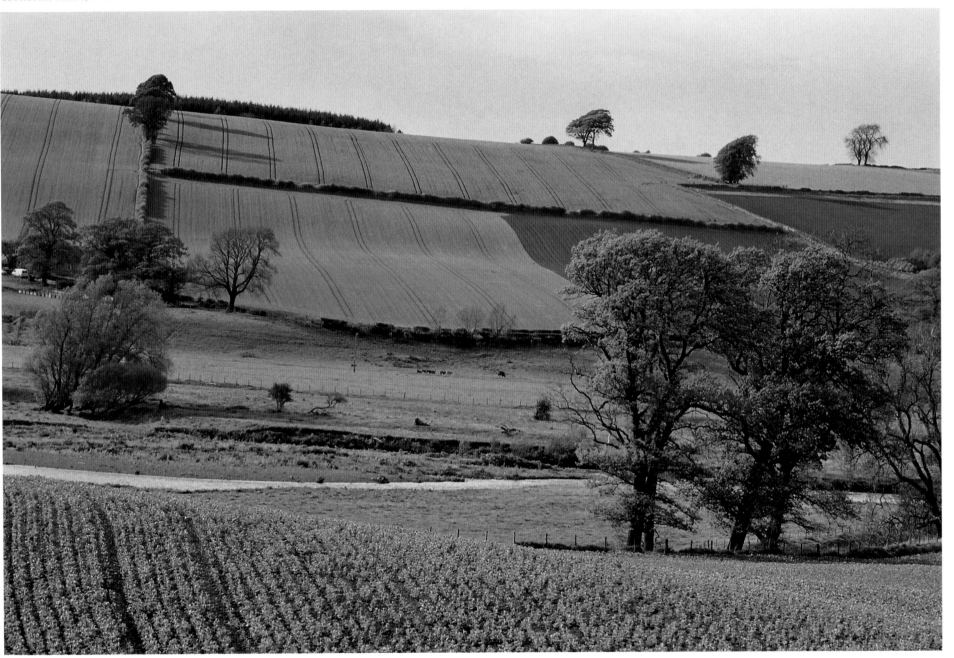

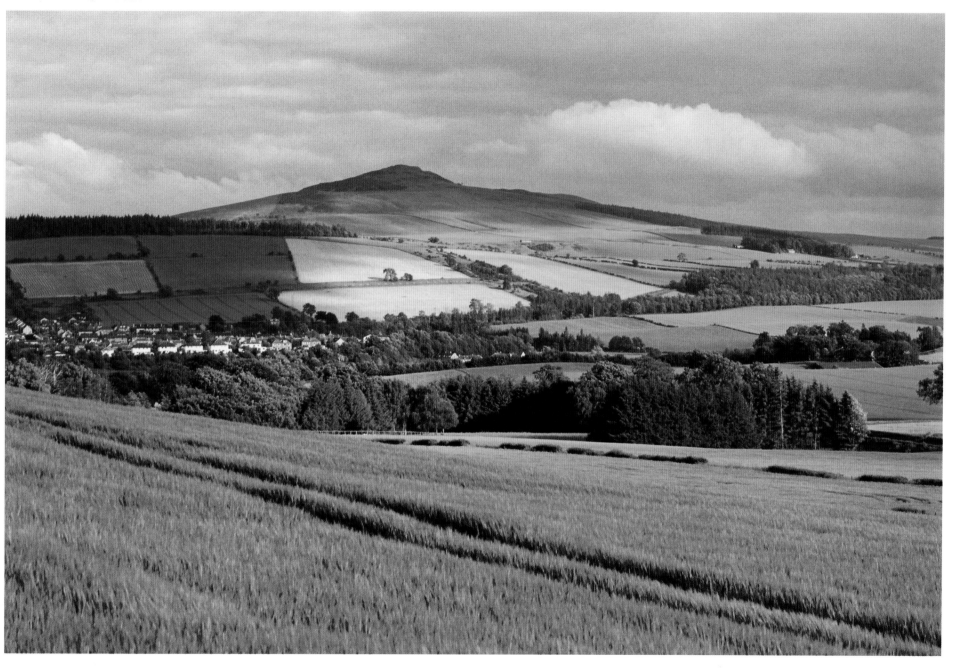

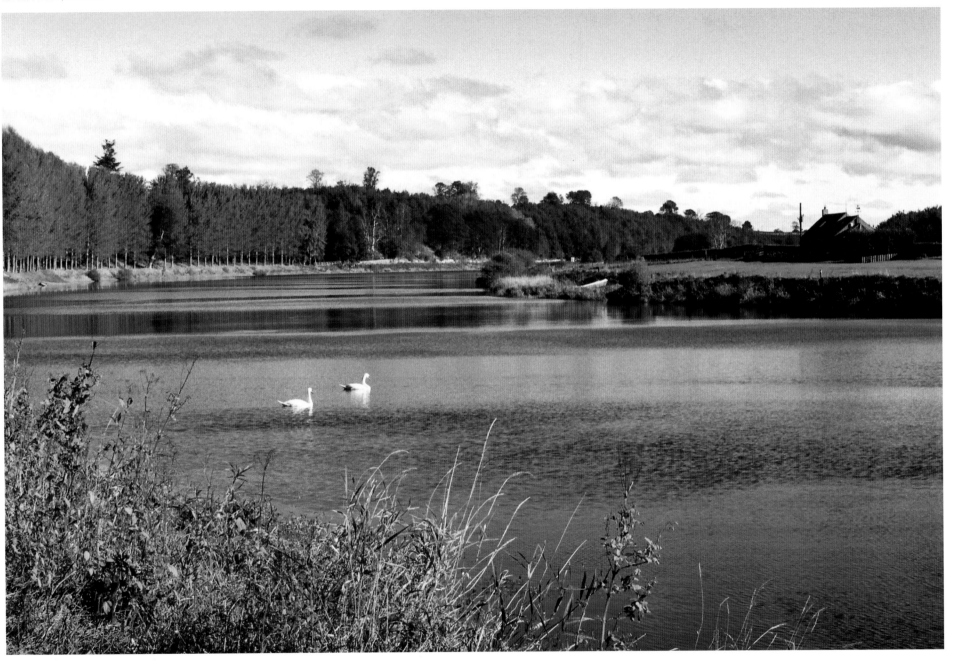

The 14th century saw the gradual reconquest of Berwickshire from the English and the assertion of Scottish royal power in the Borders. But sometimes this recovery was bought at a very heavy price. In 1460 James II laid seige to Roxburgh Castle and proudly had his heavy artillery trundled forward. One piece blew apart and shards of wood ripped into the king's thigh. He seems to have bled to death. A hasty coronation was arranged at Kelso Abbey and Queen Mary rushed her son across the Tweed. In the presence of most of the Scottish magnates, the little boy was consecrated and a crown set on his head at the high altar.

The castle was *doung to the ground* so that it could not fall again into English hands. And the busy town of Roxburgh had shrivelled to a village and its trade had withered, a spectacular casualty of international politics. But every village in the Borders would suffer from what happened in September 1513. The disastrous battle at Flodden, fought just over the Border at Branxton, killed not only James IV and many of his noblemen, it also saw the deaths of many ordinary Borderers. At the annual common ridings held each summer, the losses at Flodden are still remembered and still mourned after 500 years. What is often forgotten is that in the midst of that tragedy lay the seeds of an even greater one; the breakdown in civil order which followed Flodden led to one of the most destructive phases in Border history.

On the periphery of the battleground, troops of horsemen were seen. They took no part in the fighting and waited at a safe distance for the battle to stop. Having circled Flodden like hungry scavengers, the 'banditti' of Teviotdale and Tynedale attacked the English camp, rifling tents and stealing horses. And later the baggage train of the retreating Scots was shadowed by troops of horsemen, but nothing came of it. These incidents were a sour foretaste of the aftermath of Flodden in the Border country. The days of the Border Reivers were dawning.

• • •

Over the whole of the area of the Borders and the hill ranges around, over what amounts to a twelfth of the land mass of Britain, the 16th century saw a lawless society begin to take its dark shape. After Flodden central authority was crippled and to a practical extent, it was every man, or at least every lord for himself. The Border Reivers paid little heed to any authority except that of family and their headsman, as the chief patriarchs were known.

In essence they were cattlemen and cattle thieves. Like their Celtic ancestors of the first millennium BC and the period during and after the Roman occupation, the reivers were stocksmen who counted their wealth in

ROXBURGH CASTLE

MIDLEM

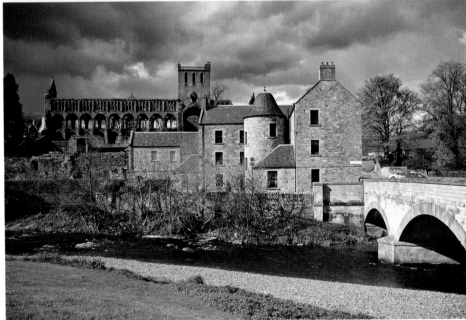

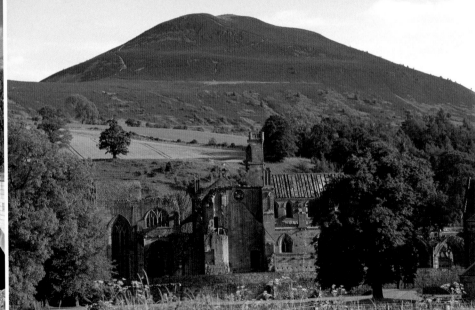

JEDBURGH ABBEY

MELROSE ABBEY

head of cattle and, to a lesser extent, sheep. And they lived in the saddle, spending summer with their herds and seeking shelter in low, turf-built shielings only when the weather had turned bad. It was an existence which bred a hardy sort of man, used to privation of all kinds up in the Border hills.

When royal and civil authority slackened in the 15th and 16th centuries, these cattlemen became rustlers, horse-riding thieves who would in fact carry off anything portable and valuable. They also had no respect for the border and notorious reiving families were as numerous on the English side as they were in Scotland. Their only loyalty was to their name, their family, and that was fierce. Any who were expelled from that web of loyalties and lost the security of their extended family and its labyrinthine ties to other, more distant relatives were labelled *broken men*. These last were made to feel so bereft that a group of broken men felt the need to band together into a surrogate family known as *Sandy's Bairns*. They knew no other way to live.

These powerful bonds of blood form another facet of the character of Borderers. Family is still of enormous importance, far greater than in the melting pot of the cities where the old ties can dissolve over little more than a generation. In the days of the reivers, family was all that could be trusted. And an echo of that habit of mind still exists in the Borders in the 21st century. When older people talk of genealogy (some seem to talk of little else), they often use the telling phrase *Aye, they're freend tae us*. Which means that they are in fact our blood relatives. It is a fascinating relict of those dangerous times 500 years ago.

To most writers, historians and novelists the Border Reivers are attractive. They supply drama, galloping tales of derring-do and many memorable moments and phrases in what was an otherwise dreich period of our history. Consequently these horse-riding thieves have become unrecognisable, seen as romantic, even heroic, and over time as somehow representative of the Borders. The letterhead of the local authority is decorated with a drawing of a steel-bonnetted reiver with his pony in the background. Which is a pity. The story of the Borders is studded with glittering achievements, and yet we choose as our representative image an illustration of one of a group of people who created nothing except trouble, who were motivated solely by personal greed, who killed, burned, raped and stole wherever that greed might be slaked. They contributed nothing to the Borders except some notorious items of vocabulary, and it is to the reivers that we owe a doubtful debt for words like *blackmail, gang, gear, red-handed* and much else.

But these men grew very powerful as the 16th century wore on. Some of the more aristocratic

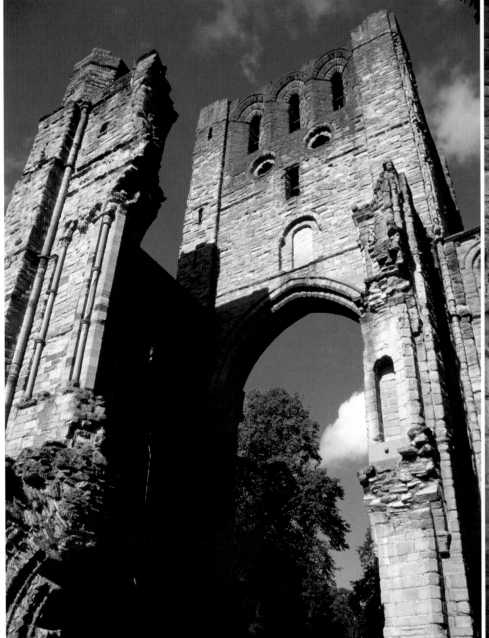

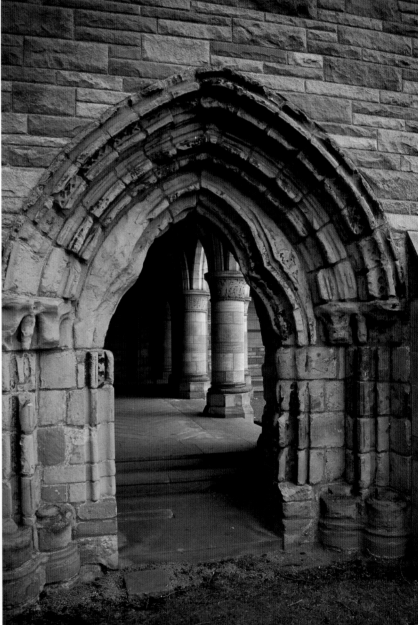

warlords, like the Scotts of Buccleuch, could put thousands of men in the saddle in a morning. Able to raise small armies at lightning speed, they could have posed a clear and constant political threat to the kings in Edinburgh, just as the Highlanders did in the 18th century. But they were simply greedy, little concerned with politics beyond the Borders, and interested only in what they could steal and carry away with them.

The best representation of what the reivers looked like is to be found in Galashiels. The magnificent equestrian sculpture outside the old town hall is only another example of the glorification of these appalling people, but it is an accurate one. Of particular note is the rider's pony. It looks small for the man and all his heavy kit, and his legs dangle below well below its belly. But in fact these horses were the reivers' secret weapons. Known as *Galloway Nags*, they were tough little ponies capable of feats of great endurance, and had an ability to

travel very long distances over difficult terrain with absolute surefootedness, often in pitch darkness. They also had to be versatile and have the skills of American quarter horses while herding and cutting out cattle, and sometimes to do duty as cavalry ponies when their riders were forced to turn and fight. In many ways the skills of the Galloway Nags made them more heroic than the unsavoury sorts who rode them. Sadly the breed is now extinct, but its close cousin, the Highland pony is much admired for its stolid temprament, and often used in riding schools to teach children how to stay on a horse.

Another, unexpected side of the culture of the reivers has found its way into modern Border society, and that is shame or embarassment. What these men called *honour* was very important to them, for some reason. And if that honour was impugned, they would exert themselves greatly to defend it. The corollary was

feuding and in the 16th century Border country, it was endemic. Feuds could last for many generations and involved killings long after the details of the original slight had become hazy. In the Borders today, honour is still important, people still care what others think, there is social shame, although mercifully few feuds ever seem to develop into anything more than name-calling. In a curious sense this touchiness is appealing and shows how connected Border society remains. Feuds and honour depend on an understanding of history, however partial, and it cannot be a backward instinct to wish to retain a good name. Elsewhere too few people care about such things.

The reivers are also remembered in more tangible, more obvious ways. Each year the Border towns celebrate festivals with the generic name of *common ridings*. The oldest, at Hawick, Selkirk, Langholm and Lauder originated with an ancient need to protect and

maintain the boundaries of the common land upon which the townspeople depended. Around midsummer large groups, often armed, would walk or ride around the bounds and check if there had been any encroachment by neighbouring lairds. Markers such as big trees or turf banks were kept in good order and if ever the flocks or herds of others were found on the common pasuture, they were driven off. This was dangerous business, and often there was violence.

Out of this old necessity the Border towns have fashioned their identities. And they are very attractive. Drawing on the timeless traditions of horsemanship, from the era of the reivers and long before, the common ridings all feature large mounted cavalcades which are led by the bearer of the town's standard. These men have different titles; *Cornet* in Hawick, Lauder and Langholm, *Callant* in Jedburgh, even *Reiver* in Duns and so on. But what is unusual in all this ceremony is its egalitarianism.

Most traditional processions in Britain are led by someone considered to be important; the Queen, the Lord Mayor of London or some other grandee. They are the focus, and often the original raison d'etre. The Border common ridings are not like that. The principals are selected each year to carry the town flag precisely because they are *not* grandees. They lead processions of ordinary people who require no invitation to be there, and as they move through the streets of the town before setting out to ride the common, they are cheered on their way by more ordinary people. The common ridings celebrate community communally and not through the proxy of a hegemony, or some remote aristocrat who apparently represents the traditions of the past in whatever vague manner. The Border common ridings shine brightly because they are real and not something confected for the charabanc trade, because they set ordinary Borderers at their centre and

exhibit a simple pride in being nothing more and nothing less than themselves.

The precise historical origins of the common ridings are uncertain but Selkirk's begins to come on record in the 16th century. It was a chaotic and murderous time. A series of raids mounted by the English crown created tremendous destruction. As the most magnificent buildings on the horizon, and the least well defended, the Border abbeys were obvious targets. In 1523 and 1545 Jedburgh, Kelso and Dryburgh were fatally damaged and Melrose left in a semi-derelict state. When the ravages of war were followed by those of the Scottish Reformation, the 400-year grip of the abbeys on Border society began to slacken. As the great churches were destroyed by English artillery and their sculptures, paintings and decoration defaced by iconoclastic reformers, the wealth and power of the monasteries also dissipated.

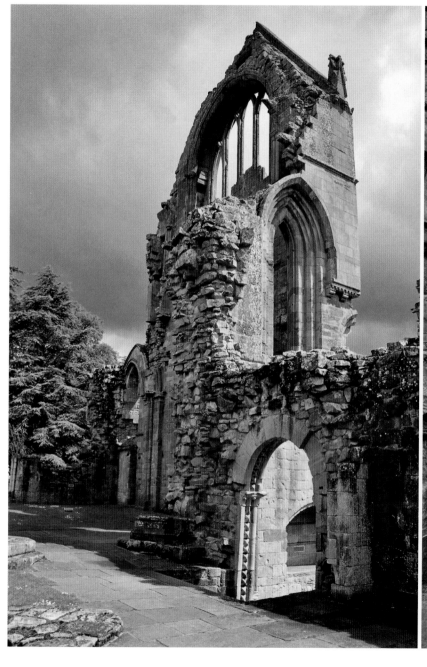

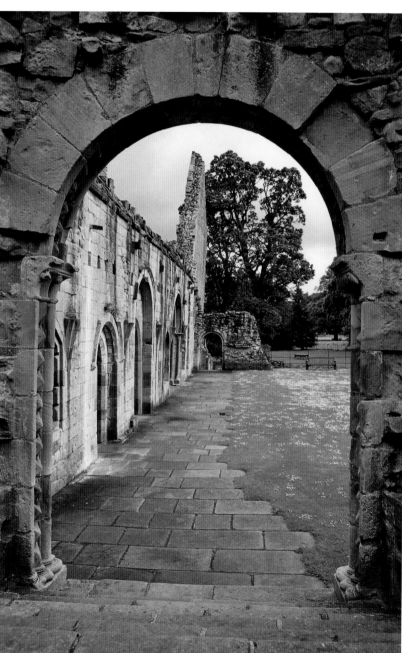

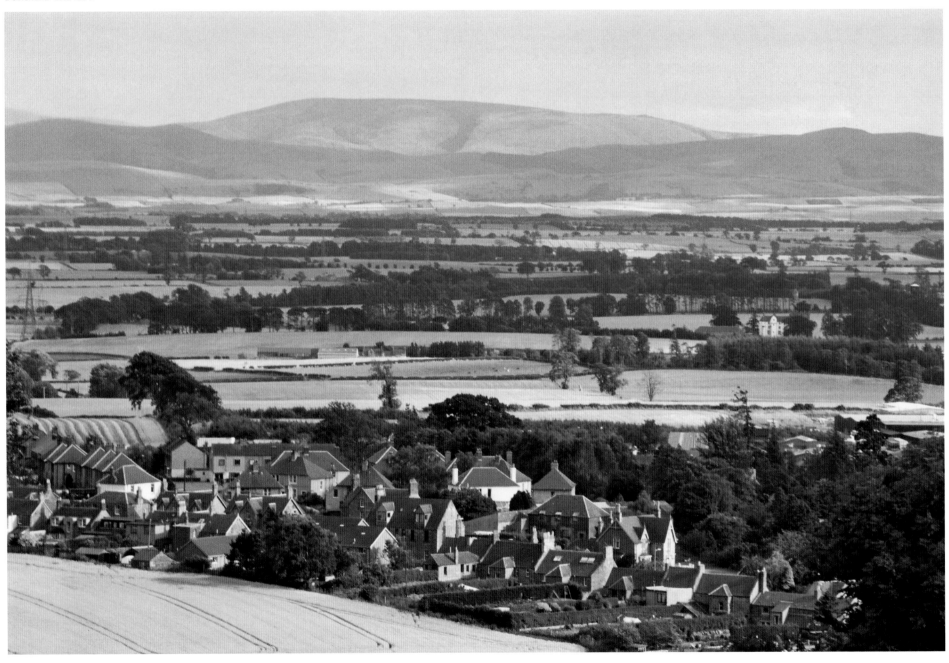

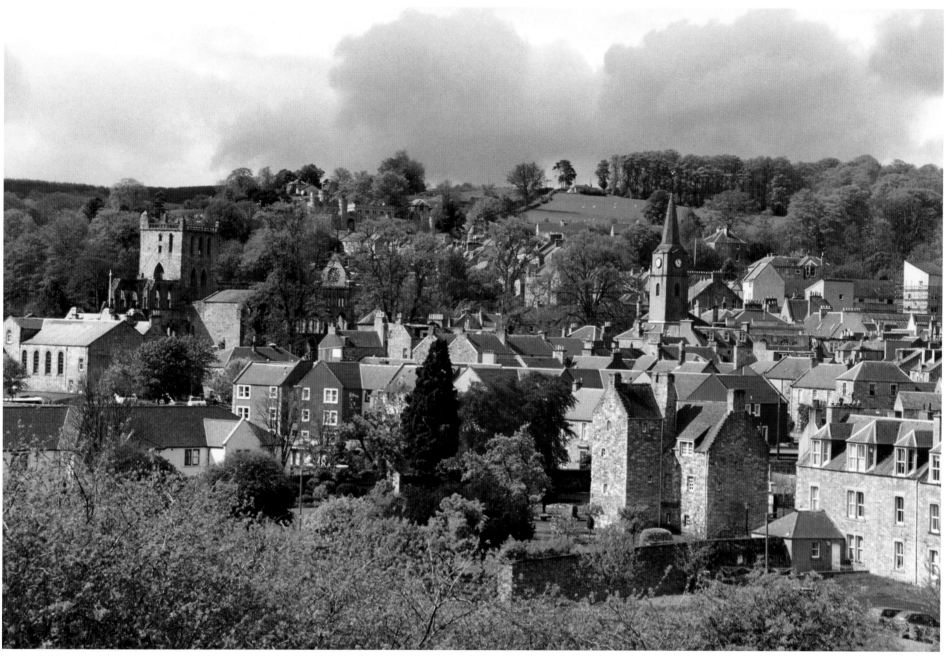

SUMMER EVENING, BROUGHTON

SUNDHOPE, YARROW

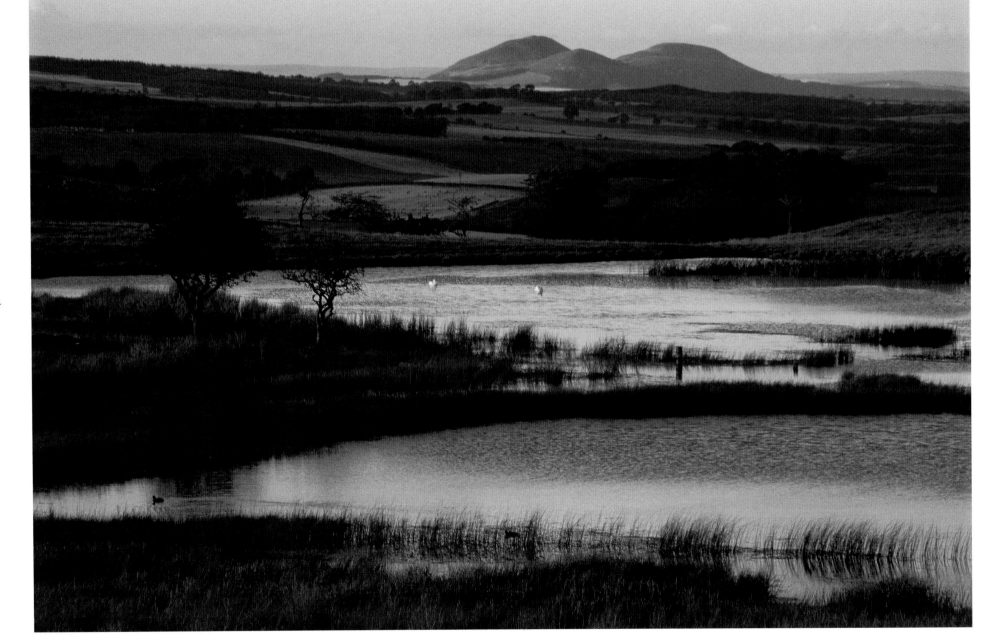

The huge estates of the abbeys were broken up and fell into the hands of secular lords, and after 1560 no new monks were ordained before the high altar. And ministers of the new presbyterian kirk took over and patched up the battered buildings to serve as parish churches. One of the characteristic constants of Border history has been the presence of great estates; first in the hands of the king, then the monastic orders and finally in the possession of powerful titled families. Sometimes the continuity appears seamless. The basis of what the Duke of Roxburghe owns in the Borders was at first substantially the patrimony of the abbey of Kelso. A very few priviliged people, even into the 21st century, still own enormous tracts of the Border countryside and that has helped to keep alive an attitude of deference to the landed gentry which has disappeared elsewhere. And it is an old attitude, passed on from the likes of the Abbot of Kelso to the Duke of Roxburghe, and one which was essential to survival until relatively recently.

On 24th March 1603 Sir Robert Carey set out from London on an epic journey. Changing horses at prearranged stops – he fell off near Berwick and his horse kicked him – Carey reached Edinburgh after only 60 hours. Climbing down off his exhausted mount in the cobbled courtyard of Holyrood Palace, he asked that King James VI be woken immediately. Carey wanted to give him the news he had been waiting for all his adult life. Queen Elizabeth of England was dead at last and had named James as her heir. Carey's amazing journey consigned the raids, the reivers and all that corrosive lawlessness to history. Once James VI had become the I, he organised a concerted police action which hanged, deported or ennobled enough Border reivers to wipe them from the pages of history. The union of the crowns brought peace, but not perfect peace.

In 1637 Borderers witnessed 37 executions. No-one could remember such an uneventful year. Raiding had virtually ceased, international conflict across the Tweed was a thing of the past and farmers could now turn their minds to improving their land rather than simply protecting what they owned. But perfect peace did not yet reign. Radical changes of a different sort took a strong hold in the Borders. The Reformation and its far-reaching social consequences began to bite hard. When John Knox called for a school in every parish, he did so because literacy was seen as an essential prerequisite to salvation. Ordinary Scots should be able to read the Bible for themselves, proclaimed the Kirk, so that they might understand the word of God directly and without recourse to the old mumbo-jumbo of a Latin-speaking priest to interpret it for them. Education would surely lead to glory and eternal life. And despite tremendous difficulties schools did spring up in every parish across Scotland and the Border country.

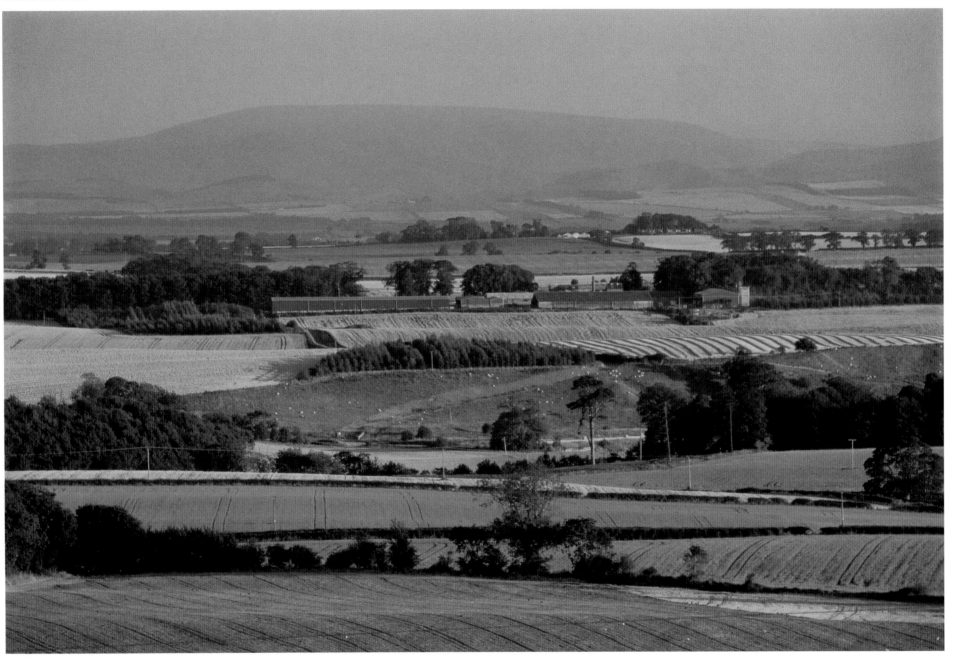

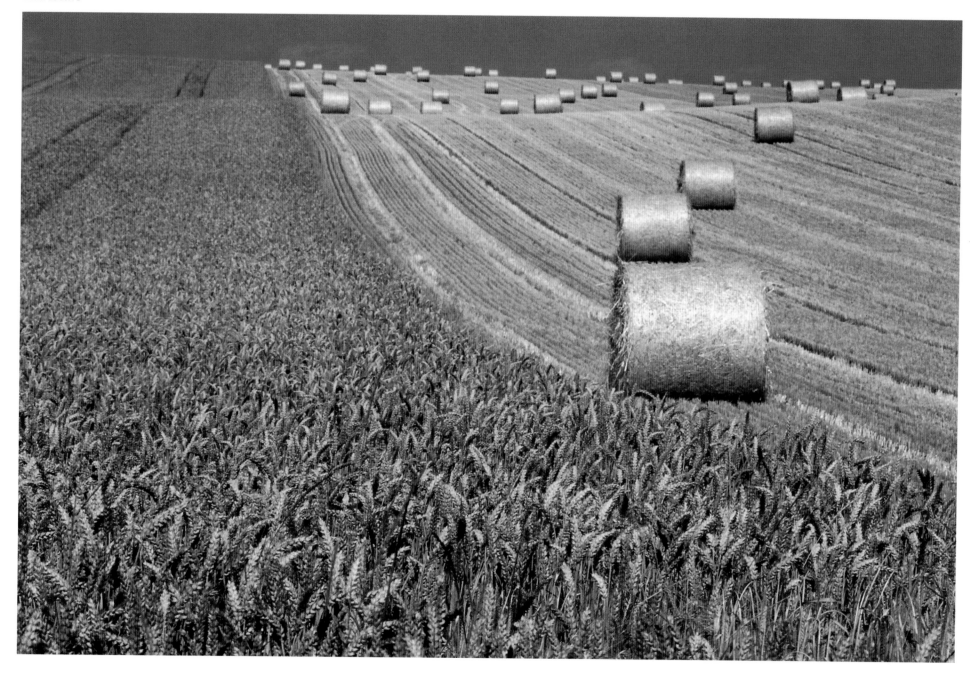

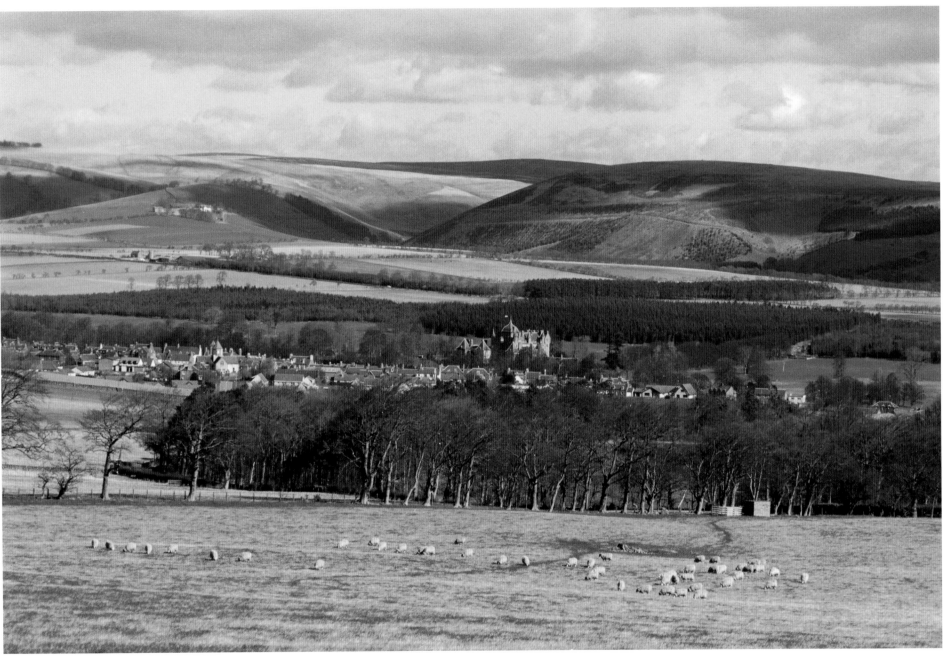

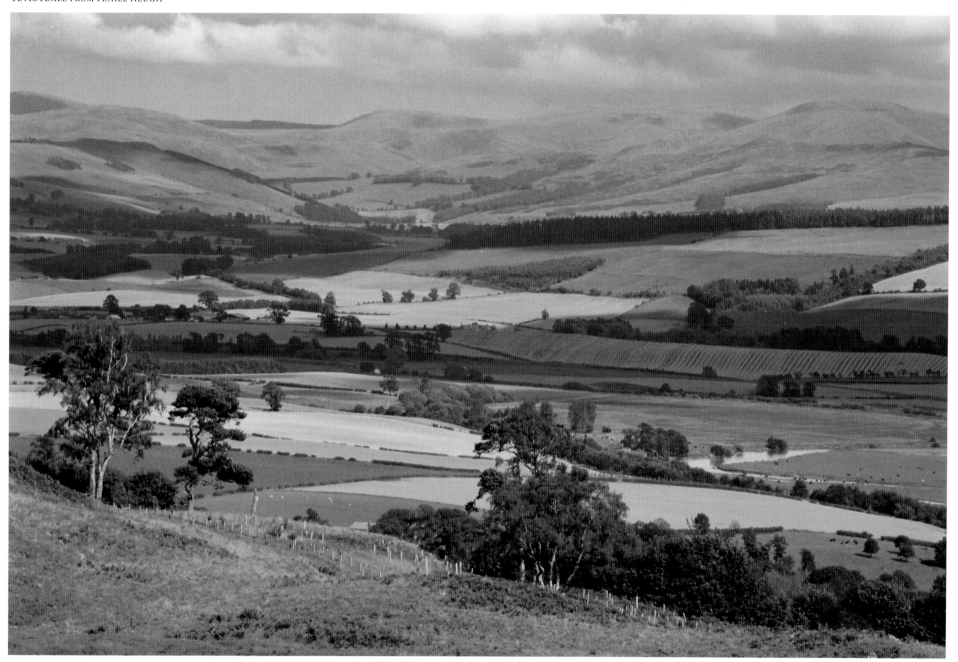

CESSFORD CASTLE

EILDON HILLS FROM LANGSHAW

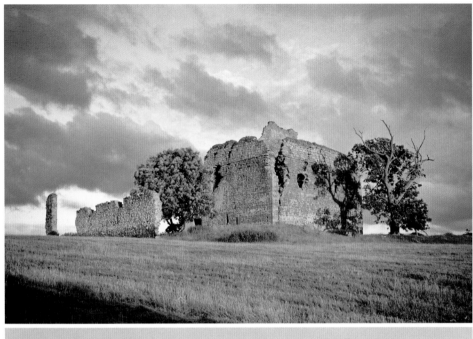

130

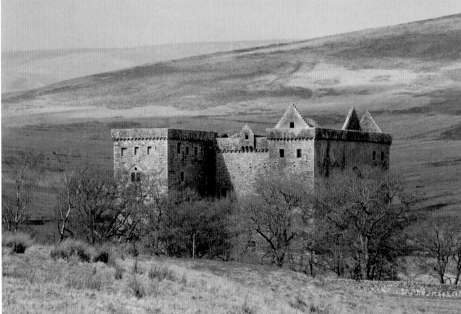

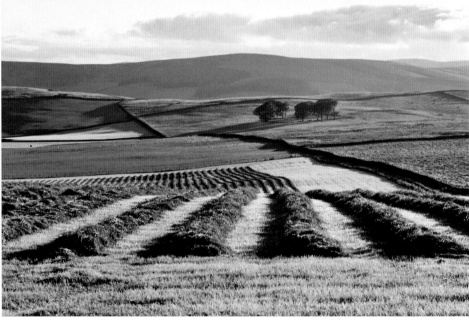

HERMITAGE CASTLE

FIELDS ABOVE STOW

Within two generations this revolution had created what was known as a godly commonwealth which could both read and write. Many positive effects flowed from these remarkable initiatives and Scotland became (and remained until the late 20th century) the best educated nation in Europe, and also, as important, a nation which valued education for its social benefits.

But something ugly was also born at the same time. To all of those newly literate adherents of the reformed Kirk, the health and purity of the godly commonwealth was a prime concern. Pollutants had to be rooted out, otherwise the salvation of all was endangered. Witch-hunts began in the 17th century and in the Borders they were enthusiastically pursued. It was widely believed that the presence of witches in a community presented the gravest threat, even more than heretic catholics, and all over the Borders unfortunate women and some men were dragged in front of the courts of the Kirk. On the most trivial of pretexts, usually nothing more than disguised spite, hundreds suffered appalling torture and were burned at the stake or hanged. And this perverted cruelty lingered on until well into the 18th century, a disfigurement that even the briefest history of the Borders should not ignore.

٠ ٠ ٠

In 1707 the union of the Scottish and English parliaments was pushed, bribed and fiddled through despite popular opposition in the streets of Edinburgh. The citizens rioted, but to no effect. The deals had been done. Those who needed to be had been paid off in English gold and the old Parliament House in the High Street was voted out of use. But for the Borders the repair came too late. Too much enmity, too much history had happened to allow English and Scottish Borderers to reunite and recreate even a shadow of the old community of Northumbria. Despite sharing similar habitats and similar habits of mind, Borderers on either side of the line had begun to look north or south. Accents are a good indicator of how much this community had diverged by 1707. Between Coldstream and Cornhill and Langholm and Longtown, there is a remarkable change in the way in which people speak, even though they live so close to each other. Northumbrians and Cumbrians sound much more like their more remote southern neighbours than the people who live immediately across the border. The change is very abrupt. And Border Scots sound more like the accents on the other side of the hills to the north than those on the opposite bank of the Tweed. Education and religion, both intimately interlinked, caused this cultural split to happen. After the Reformation, these communities of neighbours diverged and even where the

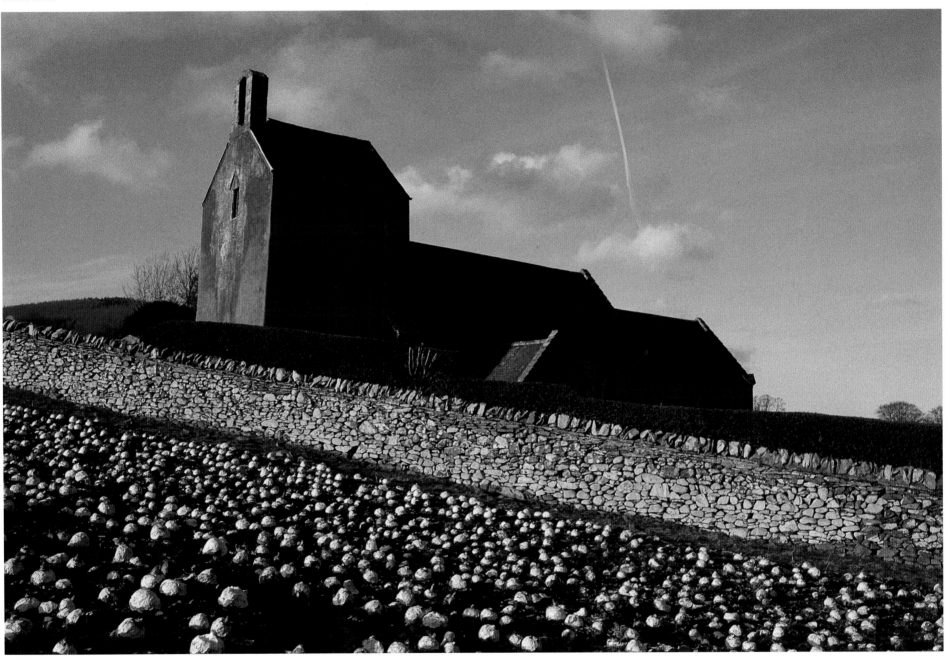

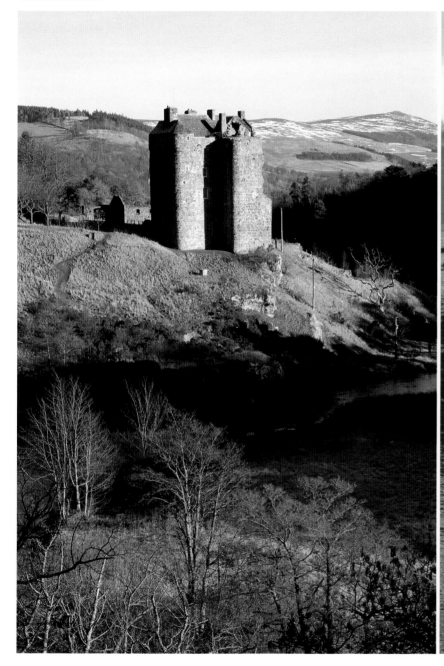

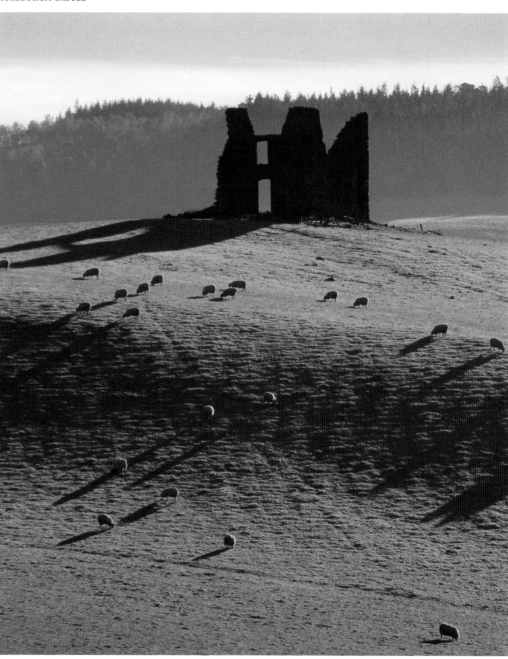

border runs along the line of a hedge or a stream, the differences either side remain striking. But at least in a united kingdom of Great Britain they could differ in peace.

· · ·

In 1700 95% of the Border population lived on the land and everyone had an umbilical connection to it. Since the Middle Ages methods of farming had changed little and the open landscape of scattered fermtouns, ox-ploughed runrig and rough pasture would have been immediately recognisable to a medieval Melrose monk or a Berwick burgess of the 13th century. Arable land was still divided into inbye rigs under constant cultivation, like a modern vegetable garden, and outbye where crops were grown on a basic rotation before the land was allowed to fall fallow and recover its fertility.

Beyond the heid-dyke lay the muir or the common where beasts went for summer grazing and farmers found fuel and building materials. The inbye was regularly mucked by the droppings of beasts, and after cropping, cows, sheep and goats were allowed to glean the stubble and deposit more fertiliser. Rights to the common grazing were controlled by a reckoning process known as souming (a derivative of 'sum') which related the amount of arable worked by an individual farmer to the number of beasts he could release onto the common. The more arable, the more beasts he could graze, and the more muck they dropped – it was a matter of elementary balance.

The only substantial enclosures seen on the old landscape were the heid-dykes separating the common grazing from the ploughed rigs, and also a few small turf or stone walls around the farmhouse to keep cattle and sheep out of the corn-store when they were inbye for the

winter. Farms were not laid out in a clear and tidy pattern, as they are now. Thistles and corn cockle grew everywhere and were harvested for winter fodder. Stones had been tumbled for centuries into the ditches between the rigs which were usually choked with weeds. Shelter from the winter winds was often scarce since there were few big trees to bield houses or stock. In fact the early 18th century Border country saw such a dearth of woodland that one of the first tree nurseries in Scotland was set up in 1729 at Hassendean, near Hawick.

Other, more revolutionary new ideas were taking shape slowly in the Borders. On the road to Blackadder Mount farm in central Berwickshire, two groups of buildings hide behind the beech hedges. In one of them sits the massive lum of a blacksmith's forge. A huge yellow sandstone mantle, beautifully chiselled and squared, projects from red sandstone mountings with flues cut into them. Below the lum is a half-broken

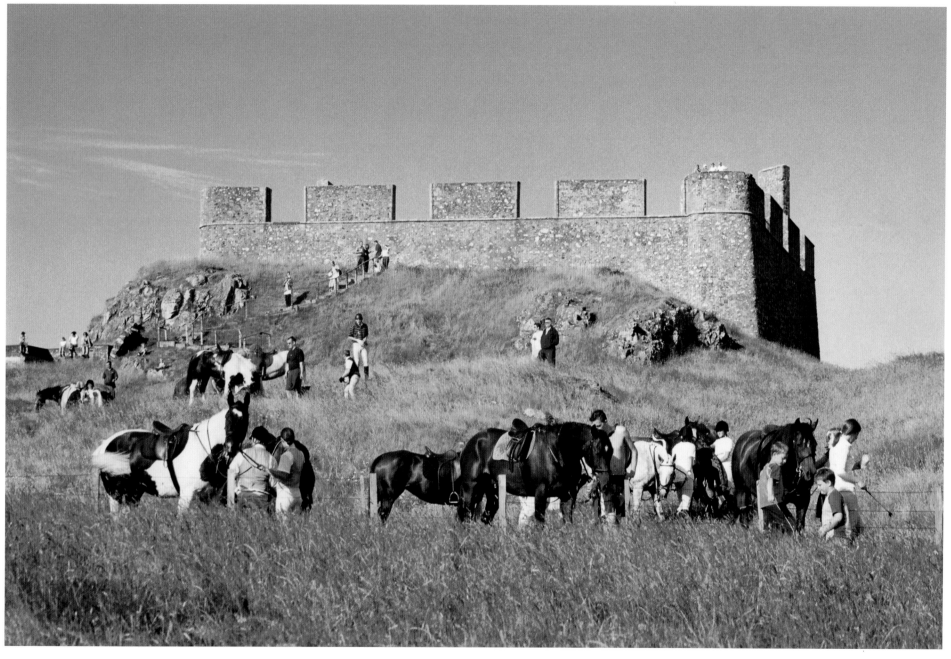

fireplace that once reached waist-height. The forge was clearly large enough to heat substantial items of metalwork.

The man who bellowed the coals into red-heat and clattered his hammer off the anvils thought a great deal about the problems of agriculture and in particular about the old Scotch plough. His powers of observation were acute, his grasp of design theory and scientific method tenacious, and his inventiveness bore the stamp of genius. James Small was unquestionably a great man, certainly one of the greatest Borderers who ever lived. And yet his name is now almost entirely forgotten and his epoch-making achievement largely unrecognised. James Small invented the modern plough and his genius changed the landscape forever.

Some time around 1740 Small was born at Upsettlington, a few miles south of Blackadder Mount, on the opposite bank of the Tweed from Norham Castle. His birthdate and origins are obscure but certainly rooted in agriculture; his father was a farmer and James served his time as an apprentice to a carpenter and ploughmaker at the village of Hutton in the 1750s. Like many ambitious young Scots Small took himself to England and found employment as *'an operative mechanic'* in 1758 in Doncaster where he no doubt advanced his skills and knowledge. Prompted by some initial discovery or conceptual breakthrough, the young man returned to Berwickshire in 1764 and was immediately set up in business at Blackadder Mount. No record exists of exactly what took place to encourage such a move but it seems likely that Small had hit on the basic principle behind the new plough and decided to come home to develop it. Despite having no capital to invest he had little difficulty in convincing a patron to help. John Renton set up Small's workshops and supplied him with all the capital he needed.

As often with world-changing inventions what made Small's plough revolutionary was a simple idea. The old Scotch plough had an iron-tipped wooden ploughshare which turned up a furrow-slice which was pushed to the side by a separate component known as a mouldboard. This was made of wood and fixed more or less flat-sided. The construction and alignment of these elements created a great deal of friction and needed the muscle-power of many beasts to pull it, usually a team of four oxen. When it did go through the ground, the furrow was not deep and the mouldboard did not turn over the furrow-slice completely. As a result a small army of plough-followers was needed to pull out weeds from under the slice and bash down big clods with a mel. These were often the children of a ploughman. And because the ploughframe and mouldboard were made of wood they wore out quickly as stones scarted at their surfaces and they often broke down.

CARTER BAR RIDEOUT, JEDBURGH FESTIVAL

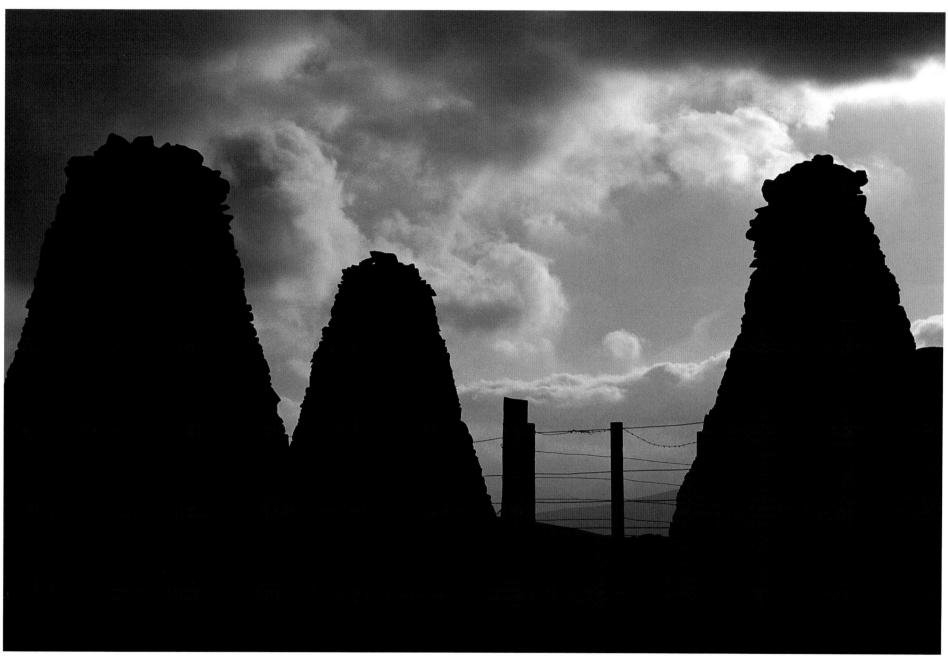

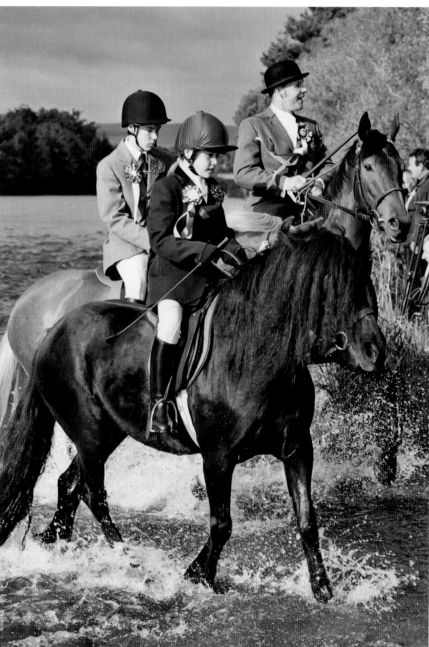

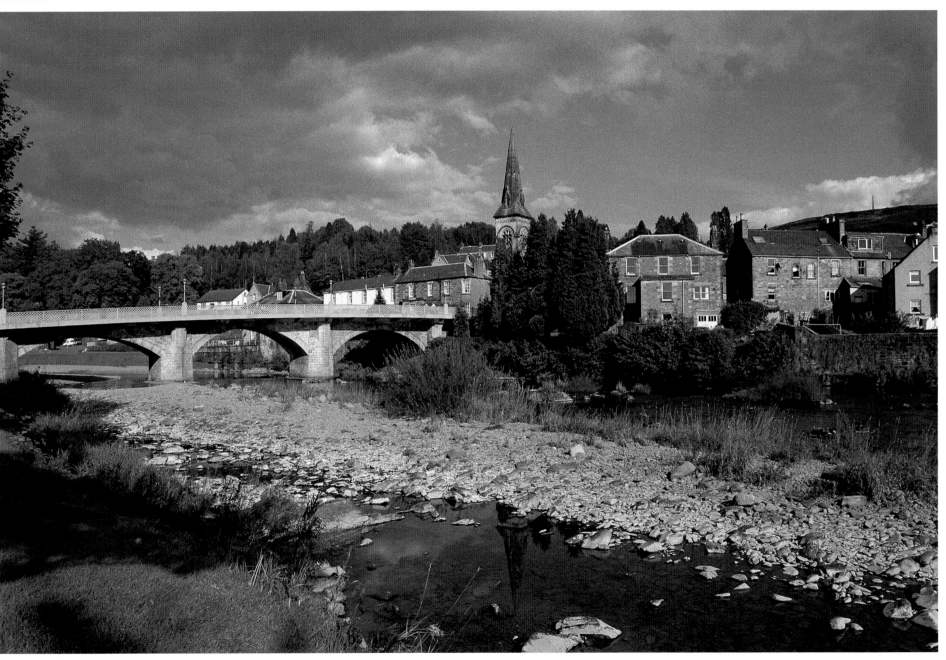

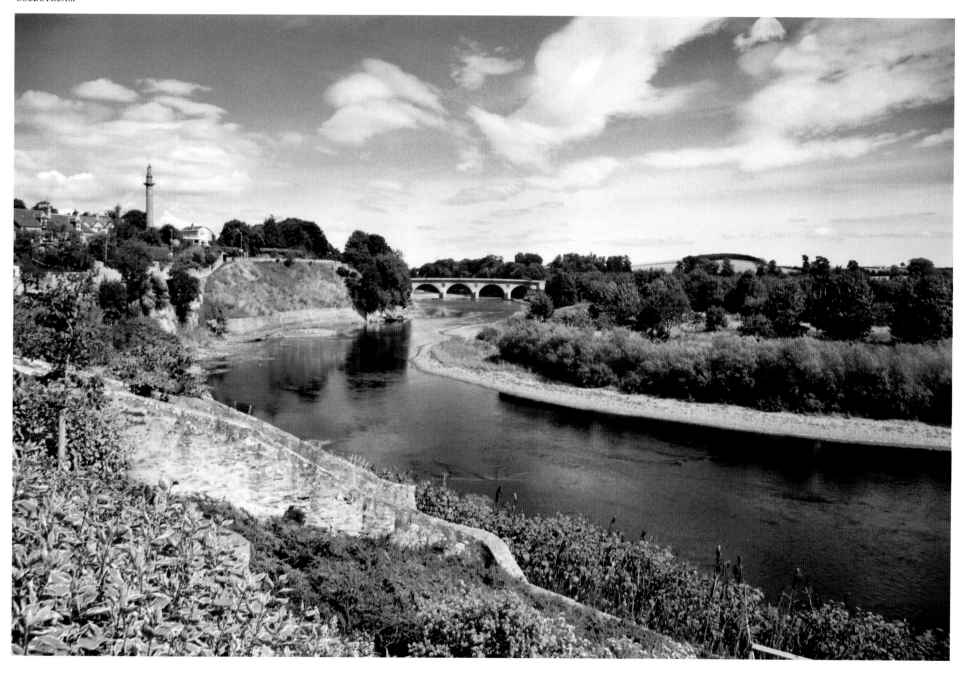

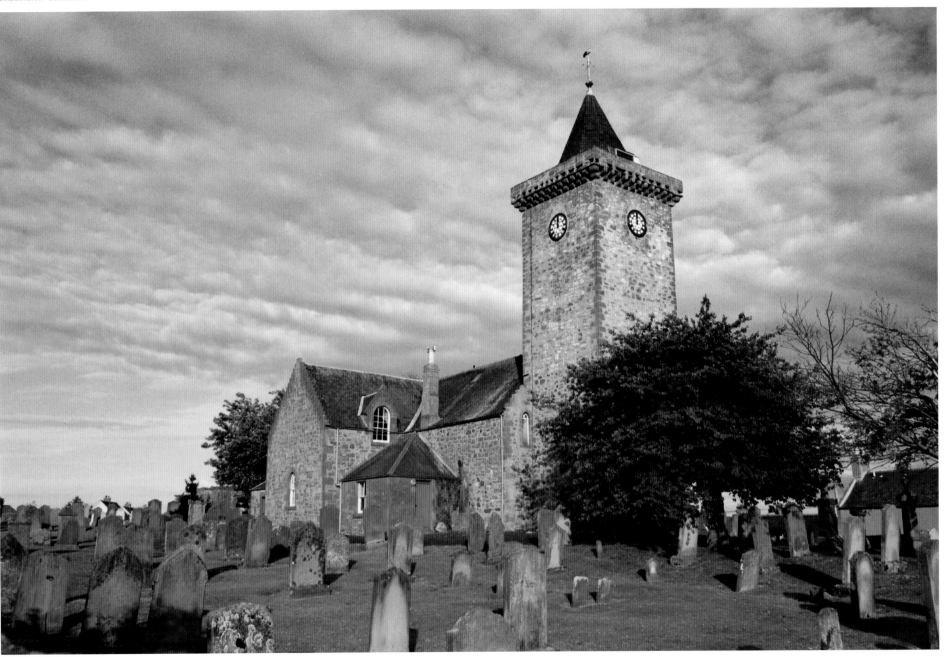

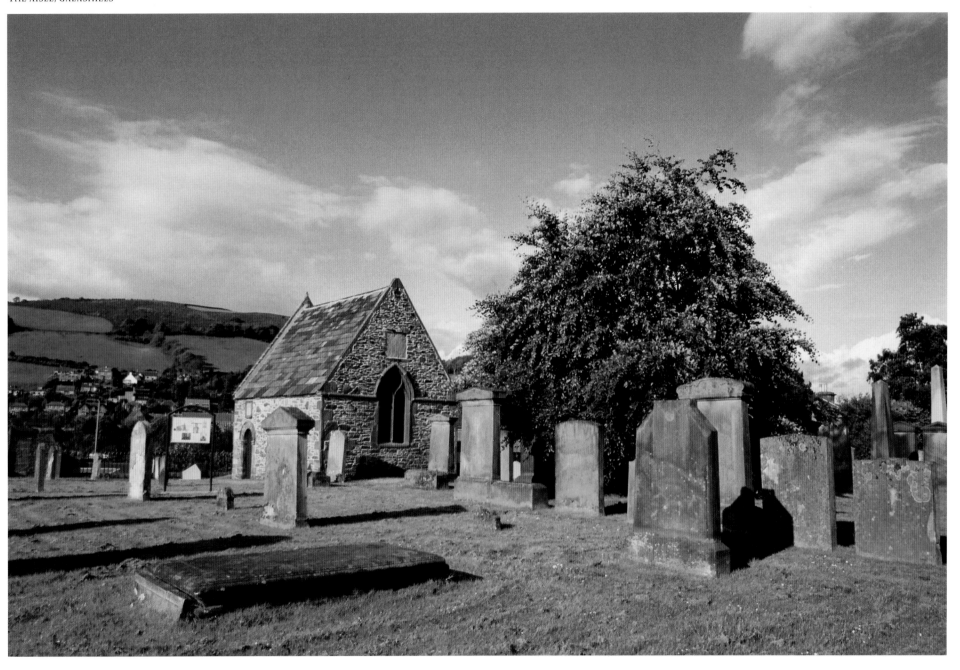

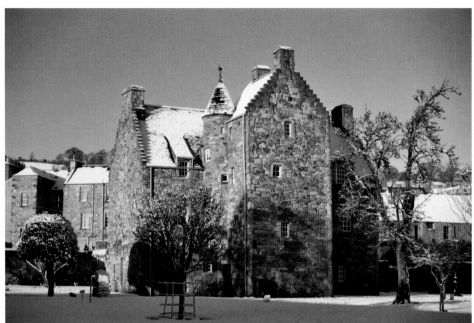

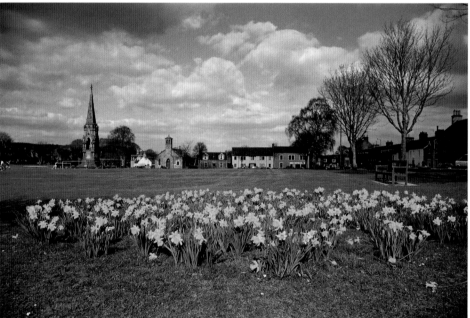

PLOUGHED FIELD

DENHOLM

James Small designed a mouldboard and ploughshare as one piece and changed the alignment and shape so that it turned over the furrow-slice completely. Crucially he abandoned wood and had the new plough cast in iron at the Carron Ironworks at Falkirk. The effect was indeed revolutionary. Because the new screwed shape (essentially the same shape as modern ploughs) encountered less friction, it could delve deeper and stay in the ground without difficulty. It could also turn over a bigger furrow-slice so completely that it buried the weeds and mulched them as additional fertiliser. And because less friction allowed the plough to cut the sod more easily, it needed fewer animals to pull it. It turned out that two strong horses could do the job well and since a ploughman with the long reins wrapped around his hands gripping the stilts could also steer them, no goadman was needed. By reducing ploughing to a one-man operation Small's invention had, therefore,

a dramatic effect on agricultural labour patterns. And also on the landscape. In essence the use of Small's plough created the fields, hedges, roads and farms we see now, and mistakenly believe are very old and traditional.

Just as James Small helped to invent a Border landscape that seems well-rooted and ancient to us now, so Walter Scott invented a romantic past which is readily accepted as only a little more than the truth. Tragic Jacobites, ingenious wizards, comical rustics, ill-fated lovers and, most remarkable of all, honourable reivers ride through the pages of 'The Lay of the Last Minstrel', 'Marmion' and the Waverley Novels to deliver to us an impossible posterity wrapped in the brilliance of Scott's narrative gifts and the absolute authenticity of his sense of place. In the early 19th century the Border country ceased to be an everyday sort of place and became instead the geography of Walter Scott's imagination. In the same way that William Wordsworth

set a fictional sheen on the Lake District, or James MacPherson's Ossian poems on the mountains and islands of the Scottish Highlands, Scott's romances and epics created the Scott Country, a place made more and more real by 200 years' repetition of his stories and the ideas inside them. To many outsiders Walter Scott invented the Borders, and increasingly, his pungent gloss on all that experience in one place has been accepted and endorsed by insiders. After all, who but a dull curmudgeon would reject the offer of a heroic past, particularly if some of those heroes really existed? Even though they were not all Scott cracked them up to be – they might have been.

Scott's literary achievements were epoch-making. He created the first best-selling books and virtually invented the historical novel. However it is his contribution to the textile industry in the Borders which is much less well understood.

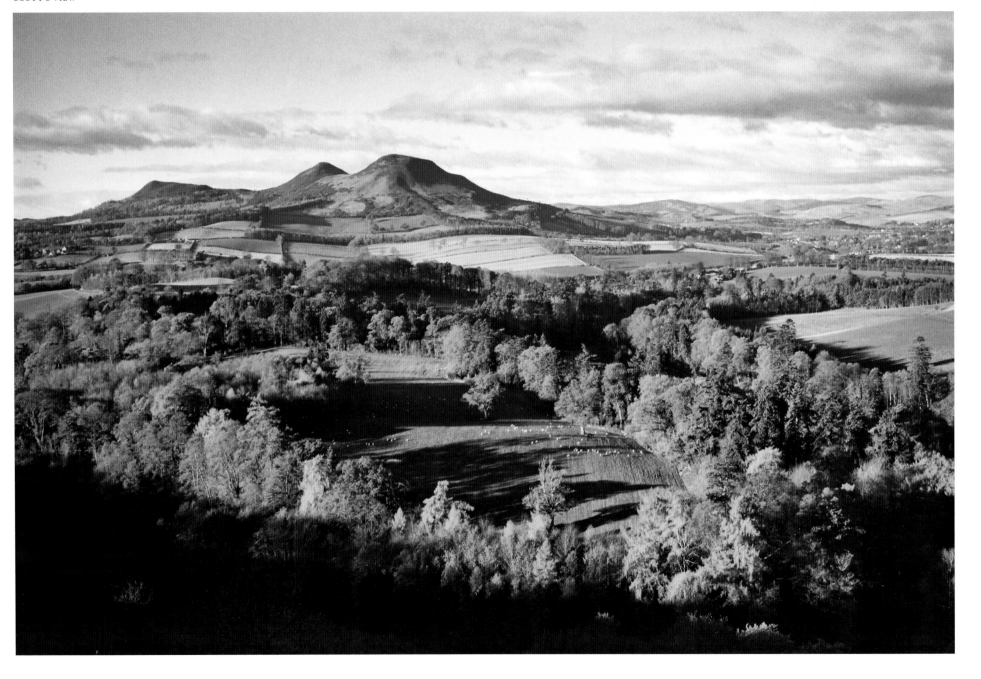

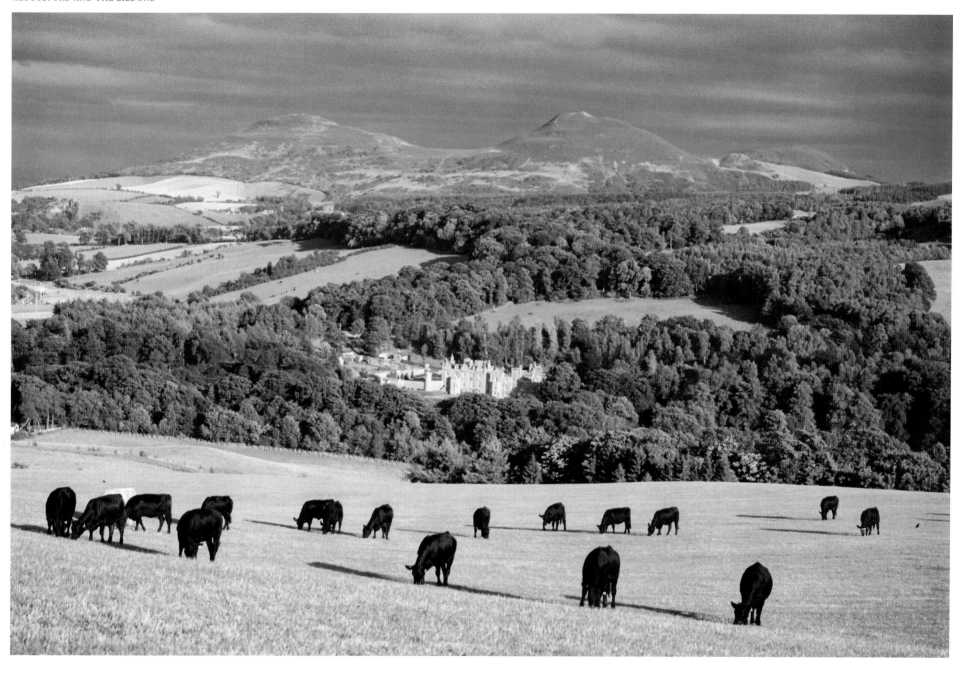

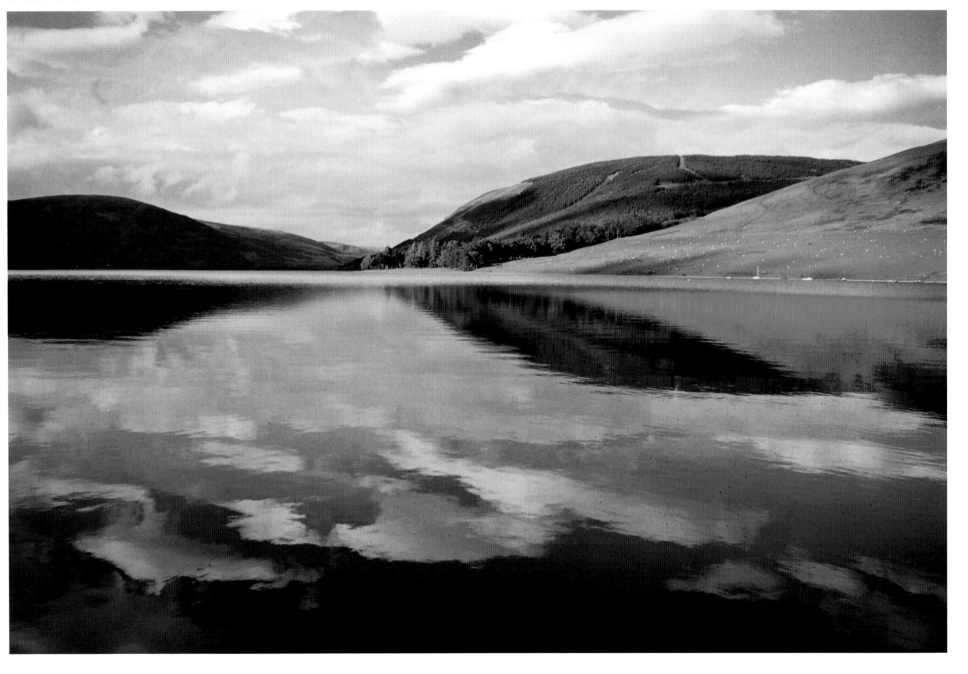

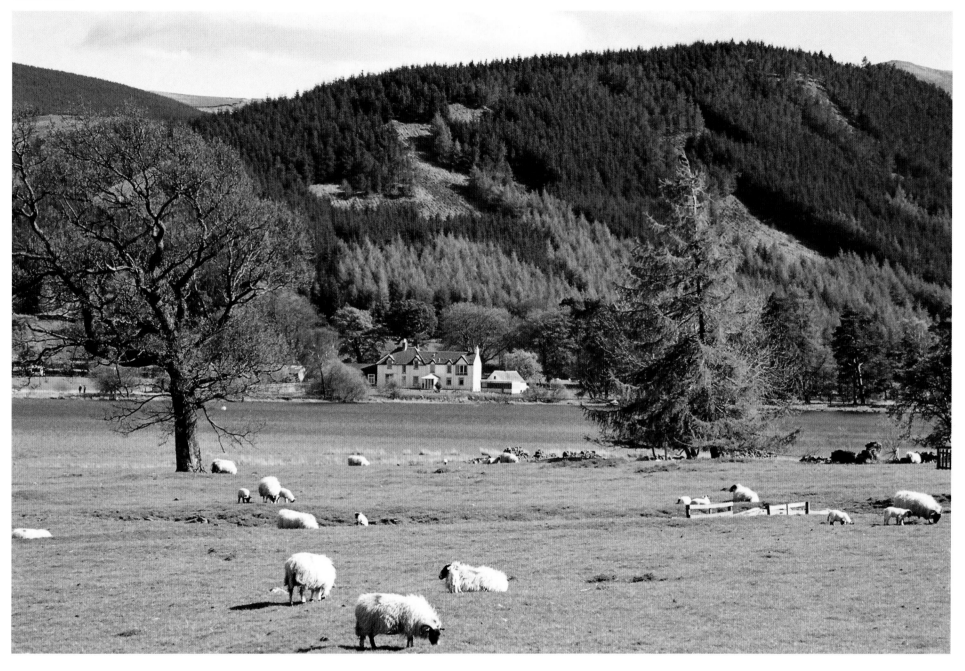

When Scott and James Hogg, a writer known as 'The Ettrick Shepherd', romanticised Border history, they created a sense of rustic nobility and simplicity which was often characterised by agricultural workers, and the shepherd in particular. Authentic touches abounded and one of these was to prove absolutely determinant. Scott and Hogg clothed their shepherds in what became known as shepherds' check or shepherds' tartan. This was the simple black, brown and white version of homespun which had been turned out by Border weavers, and particularly Galashiels weavers, for many generations. When it appeared on the backs of Scott's and Hogg's heroes, and incidentally on the backs of the authors themselves, it acquired that elusive cachet wrapped up in the adjective 'fashionable'. An Edinburgh cloth merchant called Archibald Craig left a memoir of how the shepherds' check entered the world of tailoring. Cloaks or plaids made of the traditional design became popular because of Scott and Hogg, but soon the material began to be used to make trousers and jackets. A new brown and black check was produced and that immediately became popular.

Another merchant, the altogether more dandyish James Locke, opened a shop in London's Regent Street and he took matters a stage further. In 1830 or 1832 he visited Gala to persuade manufacturers to make pattern books for his shop. They were at first reluctant but when orders began to flow in, their conservatism vanished. There is a piece of oft-repeated nonsense associated with Locke and the naming of this Border cloth as Tweed. The story runs that in 1847 the Regent Street tailor somehow misread a package from Gala as 'tweed' rather than 'twill'. This cannot be right. Locke was a tailor and knew what twill or tweel was. He was an expatriate Scot who had visited Gala 15 years before and knew fine where the Tweed ran. What Locke did was no elementary spelling mistake. In naming the Border cloth 'tweed', he was using all of his well-honed marketing instincts to associate his product with the most famous Tweedsider of the day, Sir Walter Scott.

In 1822 King George IV paid the first state visit to Scotland of a reigning monarch since Charles I. Walter Scott was made master of ceremonies and that enabled him to deliver another massive surge in trade to the Border textile manufacturers. Scott swathed the event in tartan and persuaded the portly king to sport a Royal Stewart kilt worn well above the knee over flesh-coloured tights. Despite this the visit was a tremendous public relations success, and once again fashionable society found itself in need of Border cloth, even if it was made to spurious Highland designs. As King George strathspeyed, reeled and sweated around Edinburgh, the Galashiels mills thrummed with an unprecendented surge in business.

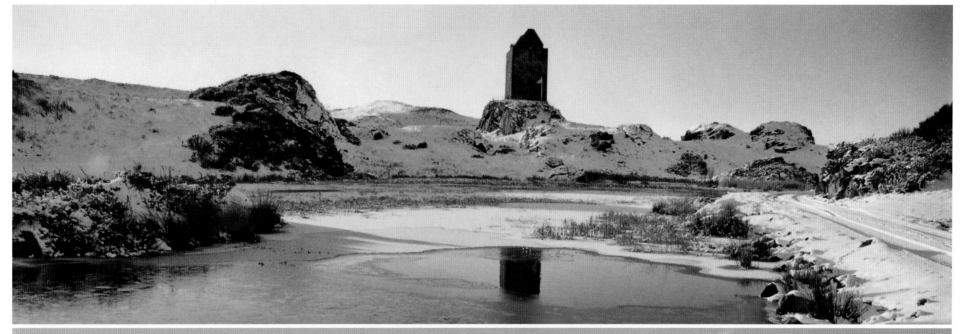

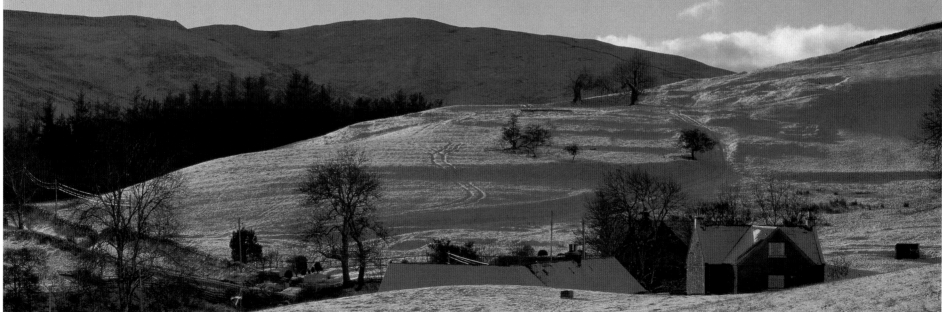

YARROW VALLEY

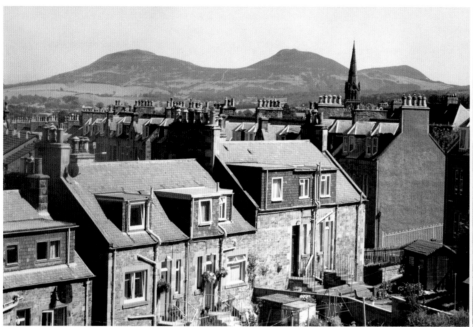

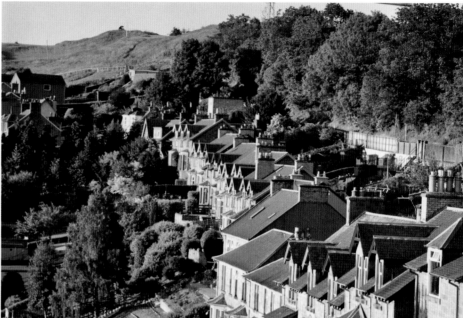

154

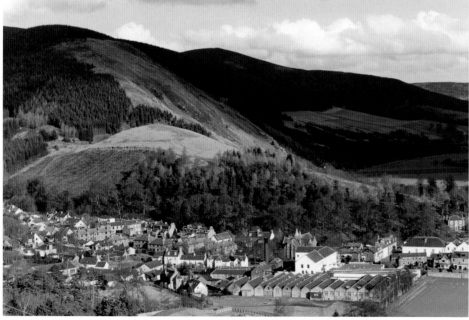

INNERLEITHEN AND PIRN CRAIG

MILL COTTAGES, INNERLEITHEN

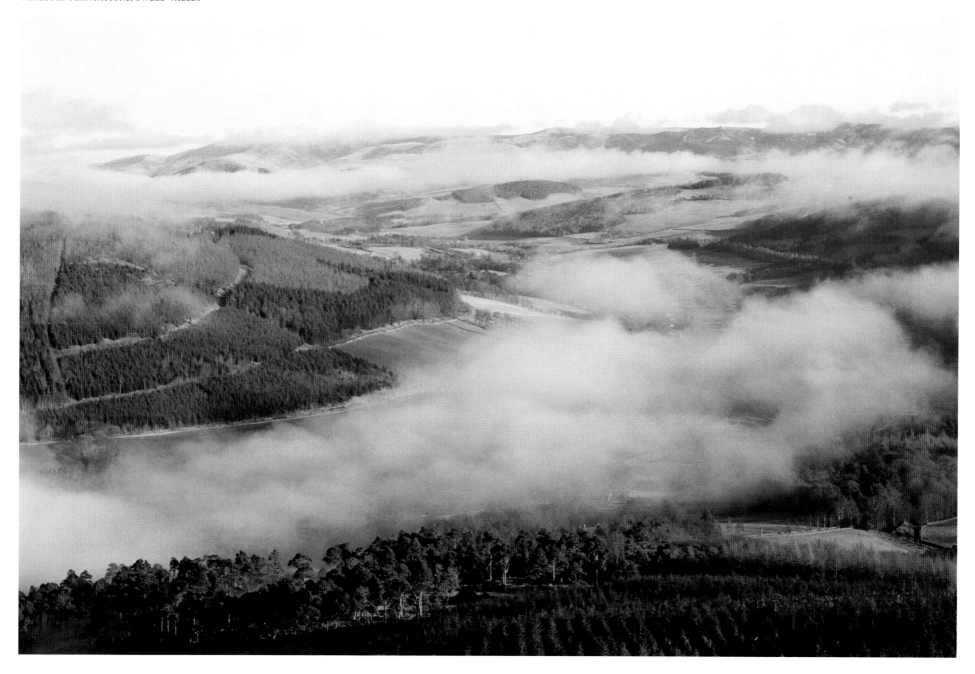

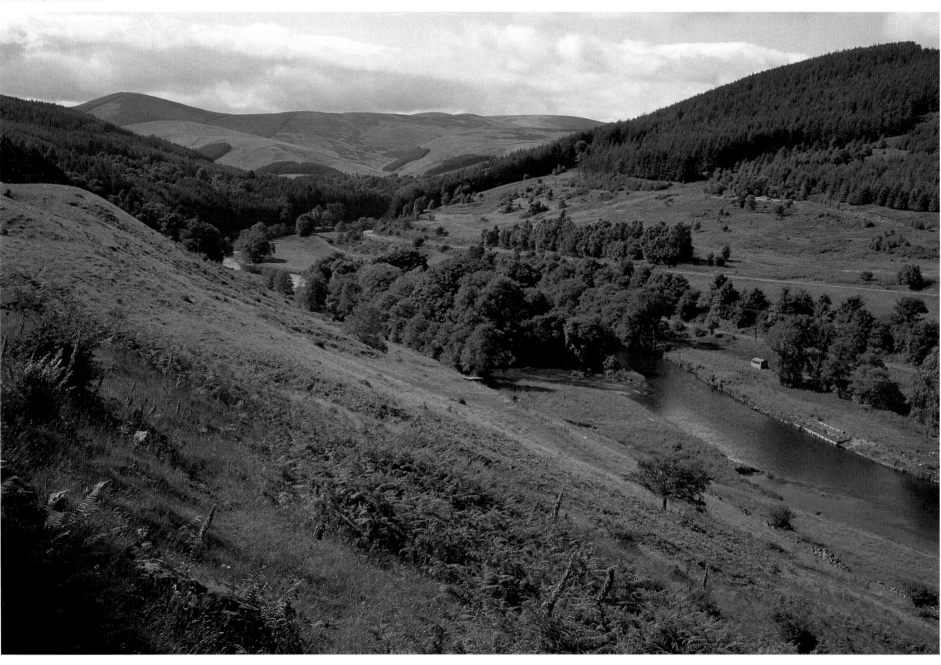

QUAD BIKE, NEAR BROUGHTON

DAFFODIL FIELDS, WARK

CARDRONA, GOLF COURSE

CARDRONA VILLAGE GREEN

158

The mill owners had Sir Walter to thank for that and at a dinner organised by the Manufacturers Corporation, they wined and lauded both Scott and Hogg. They repaid the compliment with, it was said, a passable rendition of 'Tarry Oo', an old song about tarry wool and the making of yarn.

While Walter Scott sat at Abbotsford, brooded on an immense past and used his prodigious skill and energy to write millions of words, another Borderer was collecting them. James Murray was educated at Cavers School near Hawick, taught himself the rudiments of philology, and ultimately became the first editor and compiler of the Oxford English Dictionary. It was a remarkable achievement for a man who could not afford to attend university, had to support himself both as a schoolmaster and a bank clerk, and who faced an amazing task in organising the most comprehensive dictionary the English language has ever seen. Murray established a system for compiling the dictionary at his Oxford house and saw the publication of the first volume. The OED remains primarily Murray's triumph and he was knighted by Queen Victoria in recognition. Some say that he put more than 'Sir' in front of his name when Augustus Henry was inserted between James and Murray. If that is true, then Borderers will not have let him away with such pretension. There is an amusing – and authentic – story to illustrate. When Murray came back to Denholm, he walked across the green. Knighted, homburg-hatted, spade-bearded and carrying a silver topped cane, he was met by an old woman coming in the opposite direction. She had a shawl over her head and a stooping gait. When she spied the stately figure of Sir James Augustus Henry Murray striding towards her, she stopped in front of him and looked up. 'Mercy mei Jimsie', she said, 'is that yow?' The puncturing of pretension is an characteristic Border trait and having lost none of its deadly accuracy, is still clearly in evidence today.

◆ ◆ ◆

By the early years of the 19th century Border towns were changing fast. In response to the marketing skills of Walter Scott and his friend, James Hogg, and also as a consequence of producing high quality stuff, the textile business was expanding. By 1821 there were ten mills in Galashiels and many outworkers spinning and weaving in their cottages. Across in Hawick the emphasis was on hosiery, or stocking-making for men (this was the age of knee-breeches rather than full-length trousers) and for women. With the extraordinary demands for army kit during the Napoleonic Wars, output had boomed and in 1816 an astonishing 328,000 pairs were produced on the 500 frames working in the town.

But what created sustained spiralling growth was the arrival of the railway. By 1849 it had linked Edinburgh with Galashiels and by 1862 connected with Hawick and Carlisle. In honour of Sir Walter Scott's series of novels, it was called *The Waverley Line*. The railway expanded commercial horizons immediately, opening British, Empire and world markets to Border products and in itself bringing many new jobs to the area, especially in Hawick and Newtown St Boswells.

The towns hummed with activity, new tenement housing was built as people came off the land looking for work in the mills, and all sorts of institutions sprang to life at that time. The great Border rugby teams date their existence from the second half of the 19th century, and the old common ridings were formalised and took on what has remained a predominantly Victorian look and tone. Top hats and tail coats are worn by the Hawick Cornet and his supporters, many favourite common riding songs have Victorian settings and the celebrations are punctuated by repeated hip-hip-hurrahs.

The close of the 19th century came not with 1900 but with the outbreak of the First World War in 1914. It had a shattering impact on life in the Borders, a phenomenon much understated by the lists of names engraved on the cold stone war memorials that stand at the centre of almost every town, village and hamlet. In the murderous trenches of Flanders thousands of young Borderers died a miserable death, and the effect of these sustained losses on small communities was profound. When telegrams or buff government envelopes were delivered to addresses in the streets of Galashiels or Coldstream, the whole community knew immediately, understood and mourned – and feared for their other sons. Swathes of a generation of young men were cut away between 1914 and 1918, and many took the ghost road home to the Tweed Valley.

By contrast the war ensured that the textile mills rattled along with huge orders for uniforms, kilts, knitwear and underwear for soldiers. What had perforce become a predominantly female workforce (and it remained female for the remainder of the 20th century) worked in shifts to keep up with demand. It was a cruel and chilling paradox; while their men died or were wounded at the front, Border women had never made so much money. Or enjoyed such independence. When the right to vote was at last given to women, after the end of the war, and it combined with high levels of female employment in the Borders, it changed the way in which women saw themselves. Many societies have a tradition of strong women, but in the Borders, they amounted to a good deal more than mothers, daughters or wives. Because women also had financial independence, men and marriage were more of a choice than a necessity.

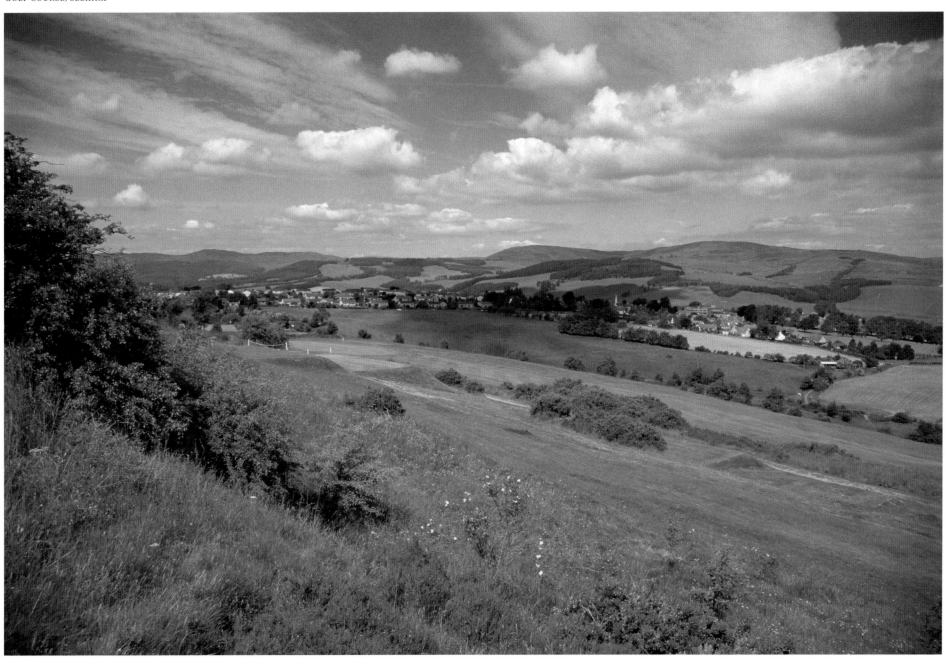

164

When hostilities ceased and the army demobbed, the artificial nature of a war economy soon became apparent. Agriculture descended into a profound decline and land values plummeted. Over much of Scotland this caused an upheaval in ownership patterns and as much as 40% of the land changed hands. In the Borders it was different. Most of the old estates managed to hang on, and some, like the Roxburghe Estates, even took advantage of the depression to increase their holdings. But what was much more important was less obvious. The high farming of the 19th century, stimulated by men like James Small, was coming to its final end. The primitive hinding system, whereby agricultural workers were employed on short-term contracts at hiring fairs held in the major market towns, was quickly passing out of use. It was a shaming business for those people who had to stand around in places like Kelso Square and wait to be spoken to by farmers who circled groups of agricultural workers like buyers at a slave market. Rural housing required to be improved, but few had the funds to do it, and that further thinned out the workforce and depressed the productivity of farms. And imports of cheaper foreign food were pricing Border farmers out of an already sluggish market. In the 1920s and 30s Borders agriculture took on a dilapidated air, one which still persists in many places, and the countryside emptied even more as workers left the old life on the land to seek employment elsewhere.

There was little enough available in Border towns. Despite the boom of the war years, mill owners had largely failed to modernise their machinery and were therefore unable to respond to changing fashion and its demands, to say nothing of competing with other suppliers who could undercut their costs. But in Hawick there was innovation and vision. Hosiery had largely given way to knitwear, and when Pringle's appointed the Austrian, Otto Weisz, as chief designer, business began to pick up. Few mills had bothered much with the notion of design, and when Weisz created new styles, used new colours, necklines and cuts, he created new markets as well. By the end of the 1930s the production of knitwear in Hawick had far outstripped underwear.

When the writer, Edwin Muir, visited the Borders to research a book he was planning on Scotland, he found that the old vigour was returning to the manufacturing towns, and that they were possessed of a spirit lacking elsewhere. Muir was perceptive and he ascribed this to a secure sense of identity, and this was greatly enriched when Galashiels, Melrose, Peebles, Kelso, Duns and Jedburgh all inaugurated their own versions of the annual common ridings. Despite some awkward nomenclature which quickly dated (*The Braw Lad*, *The Melrosian*, *The Kelso Laddie*) these festivals, or civic weeks, have been very successful in cementing communities

into an annual celebration of themselves and their much longer history. And through hard times a stronger sense of community can only be more helpful.

When the storm-clouds of the Second World War loomed on the horizon, many Borderers feared a repetition of the trench warfare and the carnage of 1914-18. But the government remembered the slaughter, were anxious about the national will to fight and rightly judged that no conscript army would again tolerate such a cavalier waste of so many young lives. In any case it all turned out very differently. *Blitzkrieg* replaced the static, dug-in fronts of Flanders and civilian populations were directly involved both as combatants and war-workers. Casualties were much reduced from what was originally feared, and the post-war aftermath was less gloomy.

Part of the reason for greater optimism in 1945 was a determination that there would be change, widespread and fundamental change in society. After the First World War, life had gone on much as before and the ruling hierarchies had remained untouched. But there was a popular perception, in the Borders and throughout Britain, that the ruling elite had failed, fought a bad war between 1914-18, and managed the ensuing peace so poorly that another war followed only 20 years later. There had to be change, and a landslide Labour victory brought in a radical administration which created the health service, better housing, and which avoided an economic recession.

In the Border towns substantial council estates were built, and being mostly low rise, the standard of construction was high and has lasted. The building styles and street layout may be mundane (the grey harling was particularly grim) but what mattered was that the houses were generally solid, weatherproof and relatively spacious, and are still in use. After the last war agriculture was not allowed to decline as it did 25 years before. Government subsidies became more important and mechanisation changed the face of the land radically. The affordable Ferguson tractor, the *Wee Grey Fergie*, abolished horse-working by the mid 1950s, and with its brilliantly designed three point linkage, the tractor could power other implements, and country places depopulated once again.

Another, more visually dramatic change also became apparent after the end of the Second World War. The Borders began to turn dark green. In 1945 five per cent of the land area was afforested, in itself a high proportion, but by the end of the 20th century, a staggering 14.5% was covered with regiments of fir trees, mainly the ugly but hardy sitka spruce. At Kielder and Craik stand two of the largest man-made woods in Europe. To make the forests more efficient and productive, ribbon-ploughing was developed to cut deep furrows to bank up the earth around young tree roots,

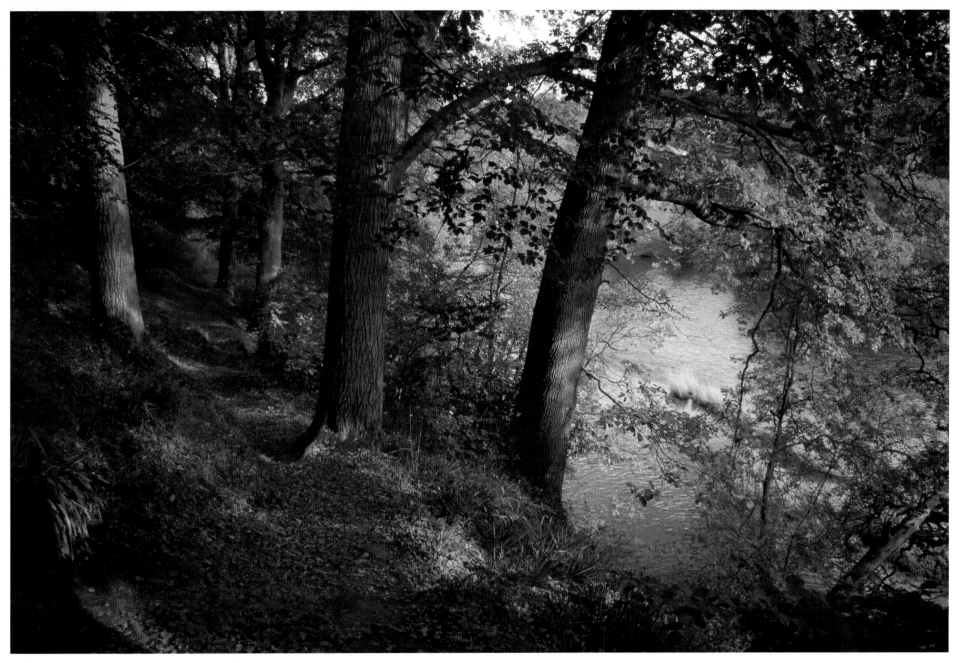

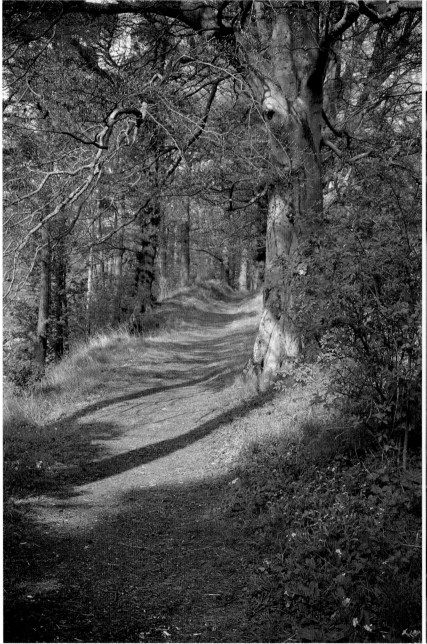

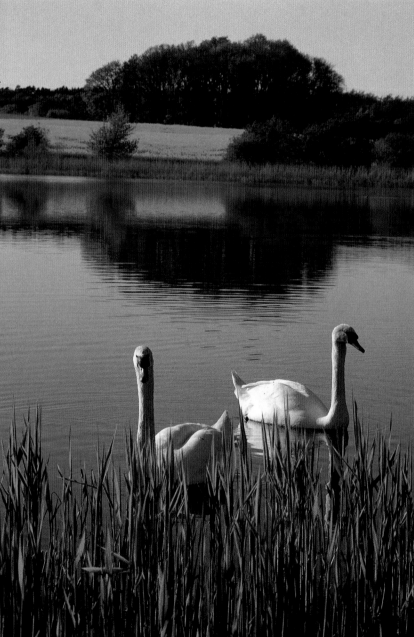

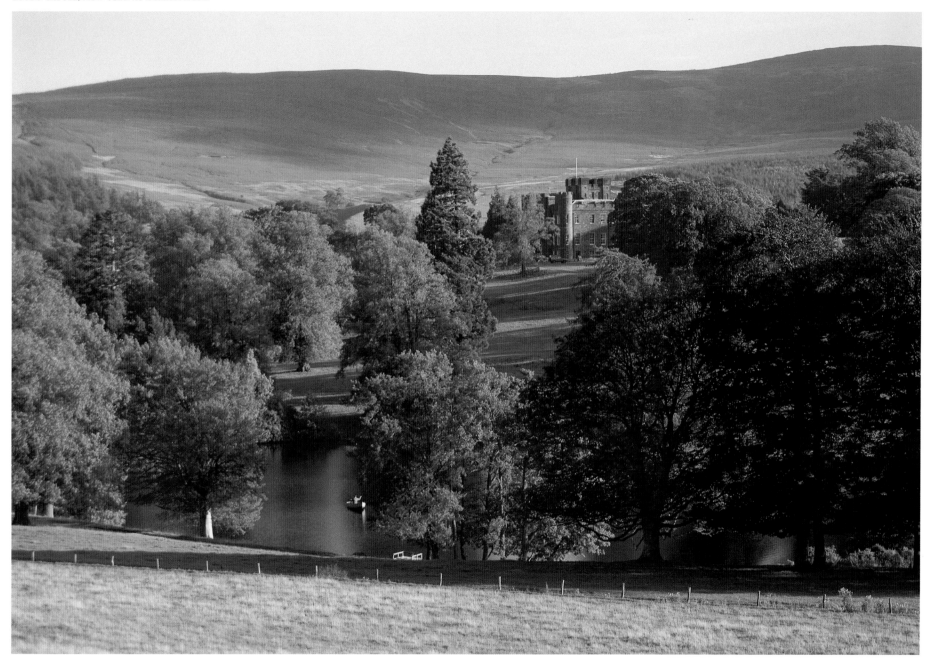

and also create better channels for drainage. But what was good for the woods was bad for the rivers, or more precisely, the riverbanks of the Borders. Deeper and better drainage in the hillside plantations led to very rapid rainwater runoff into the streams and rivers. The resulting flash-floods have cut away at the banks of rivers, particularly where they turn.

In contrast to much of the rest of Scotland, post-war political radicalism in the Borders was muted. A Conservative MP survived the Labour landslide of 1945, but at the 1950 general election, Archie Macdonald, a Liberal, was voted in. Even though he lost the old Roxburgh and Selkirk seat a year later, his victory was a reminder of old allegiances, especially in the mill towns. At a by-election in 1965 that latent support translated into a stunning win for David Steel, who went on to become Leader of the Liberal Party and the first Presiding Officer of the revived Scottish Parliament.

The Westminster MPs and the Holyrood MSPs for the Borders are all Liberals, and for the first time in nearly a century, they find themselves in a position to be more than an opposition. In the current Scottish Executive, Liberals are in coalition government with Labour and are at last able to deliver a reward to the Borders for all that loyalty. The rail link between Edinburgh and Galashiels was severed in 1969, and now it requires to be reconnected so that the area can share in the new prosperity of the capital city.

In the second half of the 20th century the economy of the Borders has been declining steadily and, just as it did in 1849, a railway might open up new possibilities. Historically too much reliance has been placed on the continued good health of the textile business and the ability of farming to absorb workers. In the event both industries have suffered very badly, and while the diversification into electronics (with particular success in

printed circuits) broadened the economic base somewhat, it was still too narrow. Major expansion has taken place in tourism, but even that has been inadequately supported. At the outset of the 21st century the Borders faces great challenges as the economy and the community who drive it seeks to convert new ideas into new jobs. There is an innate conservatism which suspects innovation and looks to tradition to sustain this place. Which is understandable. The past has been glittering, beguiling, romantic and comforting, but it is no place to dwell.

◆ ◆ ◆

Pride moves Borderers to think of the past, and it is no wonder. The matchless beauty of this place is the deposit of four hundred generations of history, the legacy of a million lives. The landscape has formed

WIND FARM, SOUTRA

MORNING MIST, VENLAW HILL, PEEBLES

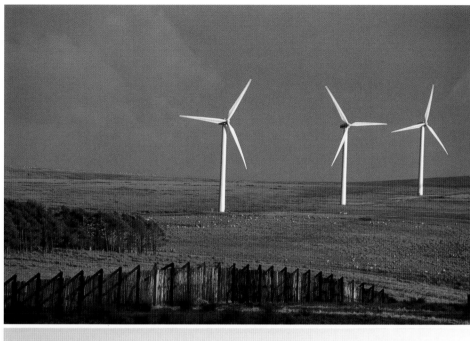

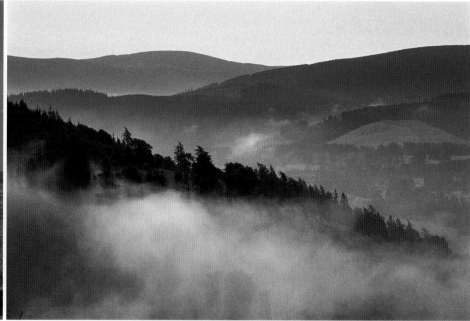

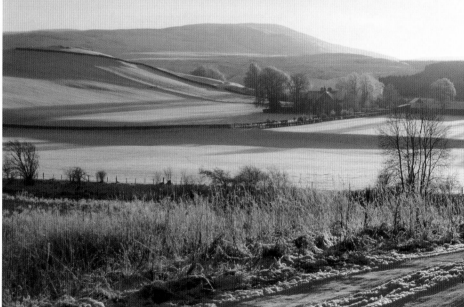

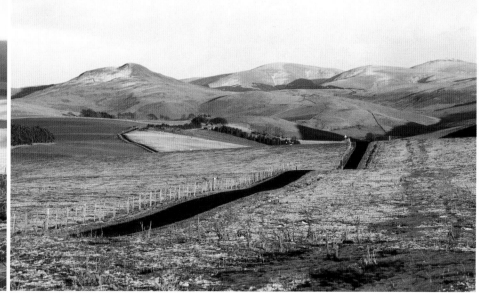

TEINDSIDE, TEVIOTDALE

WHITTON

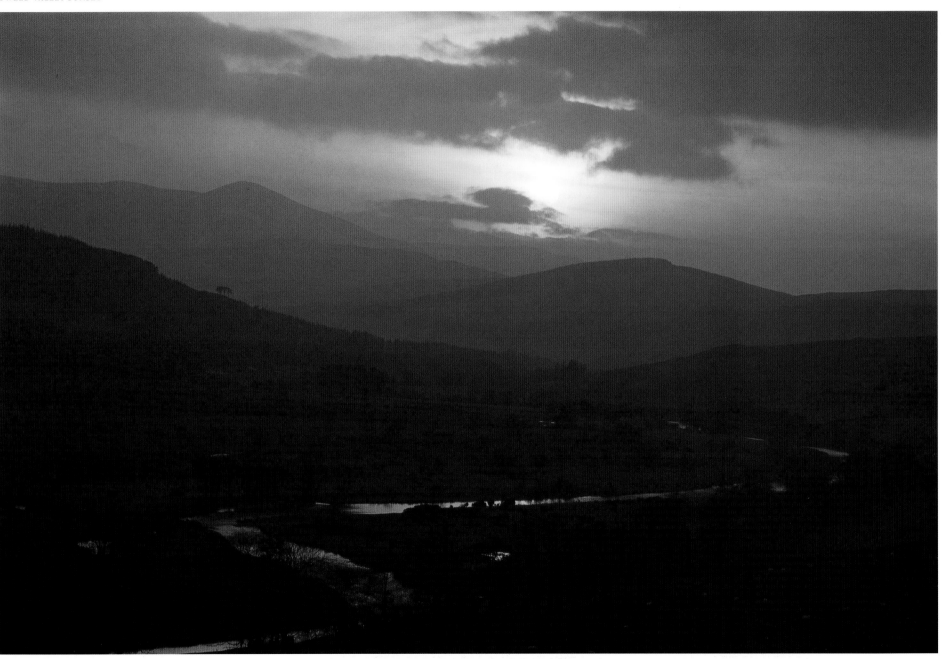

172

character and the character of the people formed it. Up on Eildon Hill North the past stretches away on every side. The singular peaks of Earlston Black Hill, the Dunion, Ruberslaw and the Minto Hills were made when the bed of the Iapetus Ocean was squeezed up into existence 450 million years ago. Lying hidden under the glinting waters of the Tweed below Melrose are the croys made by prehistoric fishermen, and at Newstead, in an oblique light, the playing card shape of the old Roman fortress can be made out. Far in the eastern distance rises the mound of Marchidun, now Roxburgh Castle, once the stronghold of Arthur. Screened by a knowe of trees, the monastery of Old Melrose nestles in the crook of the Tweed's arm, while its successor, Melrose Abbey, glows at the foot of the hill. Out to the east again, Smailholm Tower remembers the dark times of the reivers, its rocky crag jagged against the horizon.

And everywhere lie the fields, the patchwork of day-in and day-out labour somehow best seen in the evening, lit by a westering sun, flowing like a golden river down the Tweed towards the sea. Evening is best because the day's end brought rest for the numberless and nameless people who worked out their lives in these fields. Of all the monuments, grand houses, romantic ruins and picturesque tableaux to be seen in the Borders, it is the fields that are most beautiful. They are atmospheric, intimate. After the harvest, in early September, when round straw bales dot and accentuate their contours and the trees and hedges fringing them are beginning to turn russet, they look at their gentle best.

Up on Eildon Hill North, the past seems close at hand, but so too is the future. When the Celtic peoples of the Borders climbed up to occupy their roundhouses and celebrate the four festivals of the year, they sang, danced, and in the circle of firelight told stories of a heroic past. But they also looked up to their sky-gods and thought of what the future would bring. They sacrificed and prayed that the weather would be kind, the lambing would be good and the harvest plentiful. At the outset of the 21st century, the old gods have long since fled. Our prospects in the Borders are a matter only for ourselves now. But the ghosts of an immense past swirl around the summit of the hill, and they point to the glories of the landscape they made. And they quietly tell us that we should remember who we are and that we owe their memories nothing less than the promise of a glittering future.

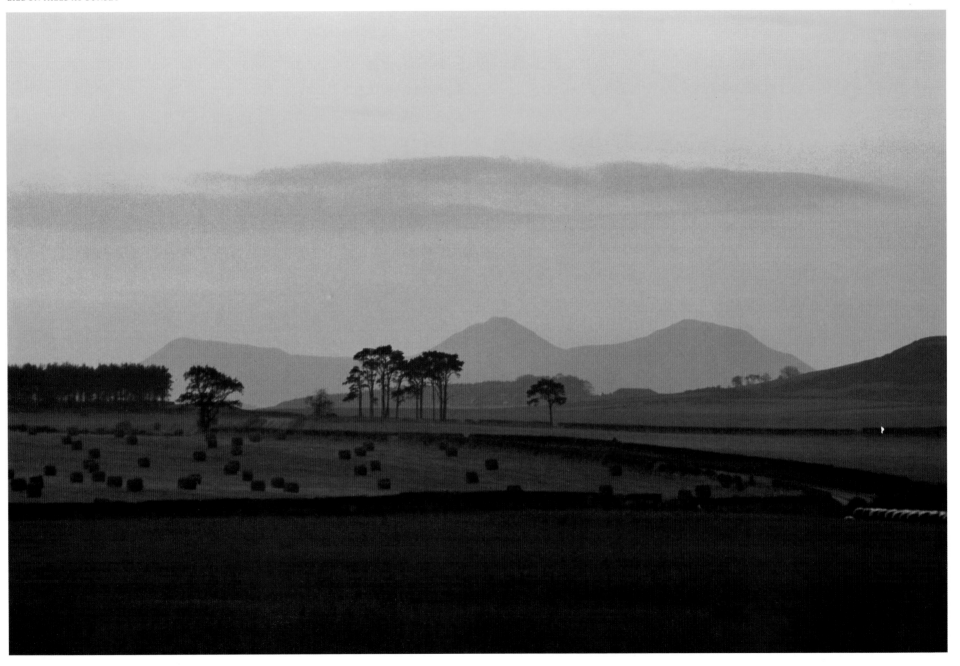